WILDFLOWERS OF
THE BOUNDARY WATERS

WILDFLOWERS OF THE

MINNESOTA HISTORICAL SOCIETY PRESS

BOUNDARY WATERS

HIKING THROUGH

THE SEASONS

BETTY VOS HEMSTAD

Publication of this book was supported in part by a generous gift from the Joseph and Josephine Ruttger Descendants Fund of the Minnesota Historical Society.

www.mhspress.org

The Minnesota Historical Society Press is a member of the Association of American University Presses.

Manufactured in China

10 9 8 7 6 5 4 3 2 1

International Standard Book Number
ISBN 13: 978-0-87351-647-1 (paper)
ISBN 10: 0-87351-647-8 (paper)

LIBRARY OF CONGRESS
CATALOGING-IN-PUBLICATION DATA

Hemstad, Betty Vos
Wildflowers of the Boundary Waters : hiking
 through the seasons / Betty Vos Hemstad.
 p. cm.
Includes bibliographical references and index.
ISBN-13: 978-0-87351-647-1 (paper : alk. paper)
ISBN-10: 0-87351-647-8 (paper : alk. paper)
 1. Photography of plants—Minnesota—
 Boundary Waters Canoe Area.
 2. Wild flowers—Minnesota—Boundary
 Waters Canoe Area—Pictorial works.
 3. Hemstad, Betty Vos
 I. Title.

TR724.H46 2009
779'.4309776—dc22
 2008041237

Everybody needs beauty as well as bread, places to play in and pray in,

where Nature may heal and cheer and give strength to body and soul alike.

JOHN MUIR, 1912

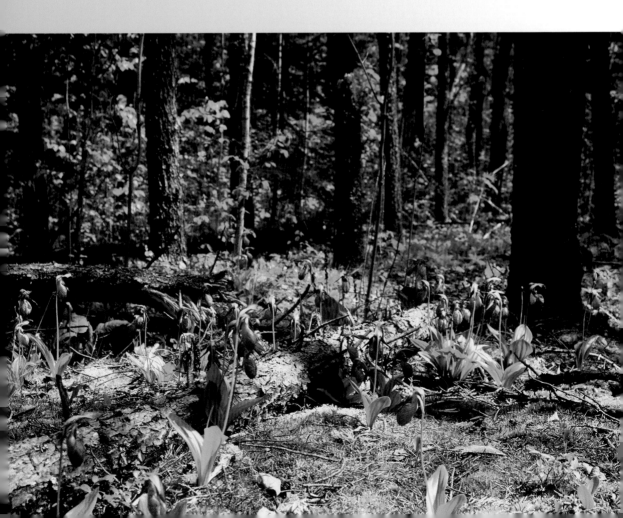

This book is dedicated to my family

Ron, Peter, Nancy, Judy, David, Paul, Juliana, Noah, Erik, Ben, and Will

May your appreciation and respect for all living things continue to grow,
especially for the wildflowers that add such beauty to our world.

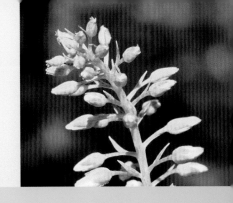

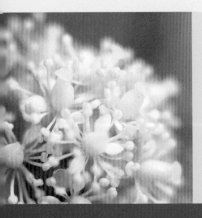

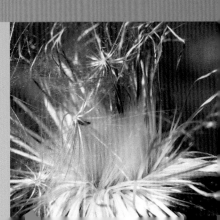

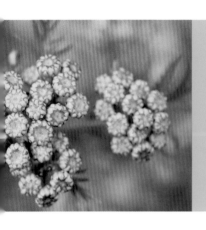

WILDFLOWERS OF
THE BOUNDARY WATERS

Betty Vos Hemstad

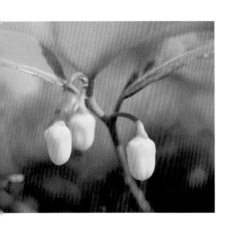

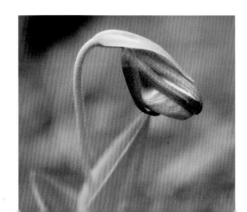

INTRODUCTION

THROUGH THE PAGES OF THIS BOOK, you will be transported to the Boundary Waters region of northern Minnesota to observe wildflowers in all their seasons—from bud to seedpod. You'll hike to a pitcher plant bog, visit the pink lady's slipper's habitat under tall jack pines, and even spend a bit of time in a canoe marveling at the water smartweed. Whether you are a wildflower enthusiast or novice, I hope the descriptions and photographs gathered here will inspire a new appreciation for these wonders of our natural world.

The greatest reward for spending time with wildflowers is the silence that surrounds you in a wilderness area, a silence interrupted only by nature's music—the song of a bird or the hum of a faithful pollinator. I consider it a privilege to be the only person to set eyes on many of the flowers in these photographs. Through the lens of my camera, you will see them, too.

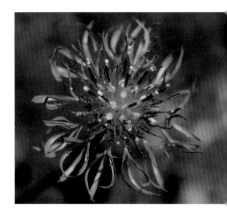

My photographs were taken in all kinds of weather—rainy, cloudy, sunny; at all times of day, from dawn to twilight; where the plants were found (except macro shots); and in natural light without enhancing filters. The photographs resulting from these techniques offer a wildflower experience very close to what you would find in nature. My tools were a 35mm Olympus camera (lacking autofocus); Kodachrome film (until it was no longer available); and only one "special lens": a 50mm macro lens with extenders. The first photograph was taken in 1984, and the last (number 623), in the summer of 2008.

Even though all the photographs were taken in the Boundary Waters region of northern Minnesota, most of these flowers are found in other areas of the United States and southern Canada. Because many arrived with immigrants, they are also found in several foreign countries. Wildflowers don't recognize fences or borders: they are constantly trying to spread and expand their territories. On the other hand, some wildflower ranges are unfortunately shrinking due to habitat loss caused by development creeping into natural areas.

Mother Nature offers many bouquets but few solitary plants. Her bouquets are exciting, whether their various colors, textures, and heights appear exquisitely arranged or in complete disarray. In this book, sometimes you must search the photograph for the featured flower, just as you would search your surroundings on a wilderness trail. My goal was to keep the *wild* in wildflowers; I "gardened," removing unwanted flowers or stems seeking attention in the photo, only when absolutely necessary.

In any book of wildflowers, hard choices have to be made in selecting which ones to include. I began by choosing the ones that were easily recognized—such as the violet or

daisy; then added those quite rare—calypso or round-leaved orchid; some with spectacular seed capsules—dogbane or marsh marigold; some with interesting buds—heal-all or bull thistle; and finally, others I thought would make an interesting collection. There are hundreds of species of wildflowers in the Boundary Waters region and thousands in the United States; relatively few could be included here. My working definition of *wildflower* was inclusive. Any flowering plant, whether weed, shrub, or wildflower, was considered, even welcomed, to be a part of this book. The only qualification was that it was growing in the wild near my cabin. Even a few thistles were invited.

The wildflowers in this book are arranged first by their blooming season, from early spring to late fall, based on my observation. The flowers within each blooming season (early, mid, late) are then arranged according to their colors (note the colored bands along the pages' edges, which offer a guide to hues). Because so many variables affect

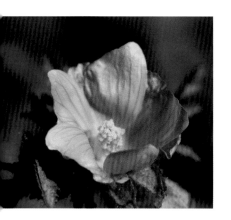

the time of bloom in any given year—especially temperature, sunlight, and rainfall—this order is simply meant as a guide to help you locate a particular flower.

This book showcases 120 wildflowers, each occupying a two-page spread. The left side offers a view I like to call "as seen while hiking." Sometimes you will be looking off in the distance; sometimes a few feet ahead; other times straight down in front of you. Most hiking shots also offer a hint of the plant's environment in the background. For a closer look at the featured flower, shift your attention to the right-hand page and find, clockwise from top left, the bud, a more isolated view of the plant or foliage, a close-up of the blossom, and the seed.

The paragraph accompanying each plant is based on information I have gleaned from writings on wildflowers or by observing nature for a lifetime. My approach is conversational, as if we're good friends, walking and talking together. A bibliography at the back of the book lists sources that offer more scientific information, facts, tales, or tidbits. Authorities I consulted for scientific names include the *Flora of North America* volumes and *Manual of Vascular Plants of Northeastern United States and Adjacent Canada* by Henry A. Gleason and Arthur Cronquist. The term *cousins* appears occasionally in the descriptive paragraphs, in most cases because they are members of the same plant family. Native plants and invasive plants are noted with these respective icons: 🌿 and 🍃.

Certain wildflowers have enjoyed many uses in the past and into the present, sometimes as a food source or as medicine. This information is provided for interest and historical value only. Do not consume any part of a wild plant or berry unless you are certain it is a strawberry, blueberry, thimbleberry, or raspberry. An exception to this rule is

the common blue violet—if it is growing in your garden where no herbicides have been used. Several of the plants described in this book are actually poisonous: respect this information and just appreciate wildflowers for their beauty.

Botanical terminology is kept to a minimum, but where essential vocabulary words do appear a simple explanation immediately follows. A reminder of the male and female parts of a flower may be helpful from the start. The *pistil* is the female part, consisting of a *stigma* (tip of the pistil that receives the pollen), a *style* (stalklike column connecting the stigma to the ovary), and an *ovary* (enlarged base within which the seeds develop). The *stamen* is the male part of a flower, consisting of the *anther* (pollen producer) and *filament* (slender, threadlike stalk supporting the anther).

On pages 252–62, you will find an additional group of twenty wildflowers of the Boundary Waters region, each photographed in one particular season. I challenge you to begin your own wildflower journey by photographing their other seasons and making note of where and when you found them. You might be surprised when you discover some of them growing in your own backyard or along your favorite walking path in the city.

When wildflowers become part of your life, you eventually relate their life cycle of seasons to the life cycle of all living things. One of the driving forces behind this book's seasonal approach is that my philosophy of life has always included "To everything there is a season, and a time for every purpose under heaven." May you see the parallels of your own life's seasons with those of all living things and recognize beauty in every corner of your life.

> *Native* 🅑
>
> *Invasive* 🍃

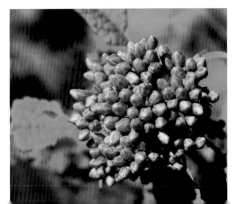

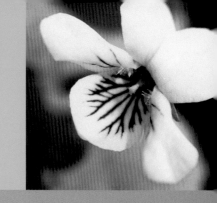

EARLY-SEASON
FLOWERS

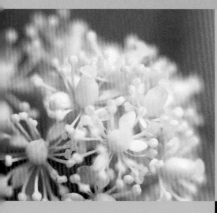

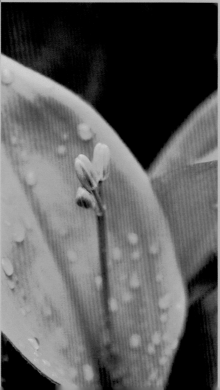

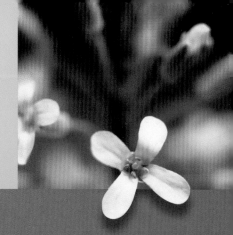

The last snowflake has melted, bright sunshine warms the earth, and the "early risers" are eager to reveal their beauty.

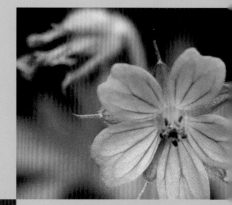

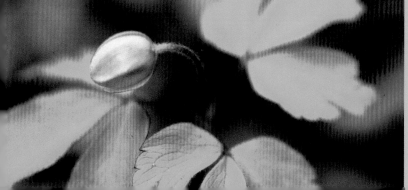

SWEET WHITE VIOLET ✿
Viola macloskeyi

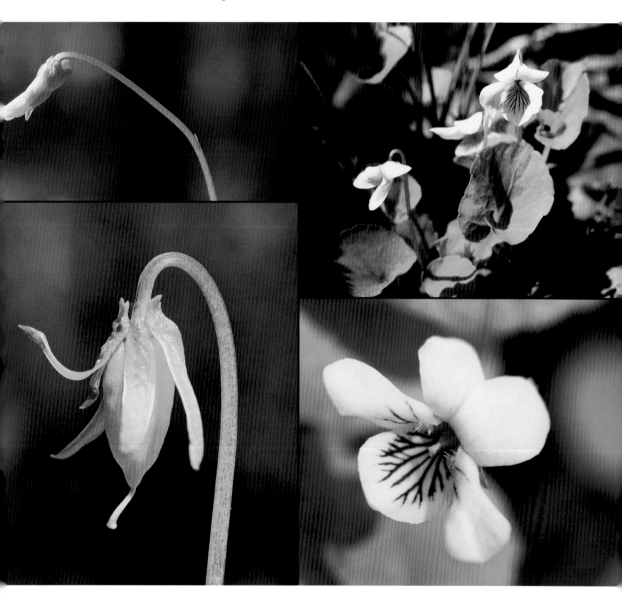

THE SWEET WHITE VIOLET is one of the first wildflowers to bloom in the early springtime. These plants seldom grow more than two inches tall, so it's very easy to miss their faces peeking through last year's dead undergrowth. When you discover them, you'll appreciate their heart-shaped leaves, their sweet scent, and their purple veins on snow white petals. Napoleon developed an appreciation for vio-lets, and he gave them to Josephine every year on their anniversary. Upon his death, violets were found in his locket, along with a curl of her hair. Even Shakespeare appreci-ated violets, writing in *Henry v*,

> *I think the king is but a man, as I am;*
> *The violet smells to him as it doth to me.*

WOOD ANEMONE ✿

Anemone quinquefolia

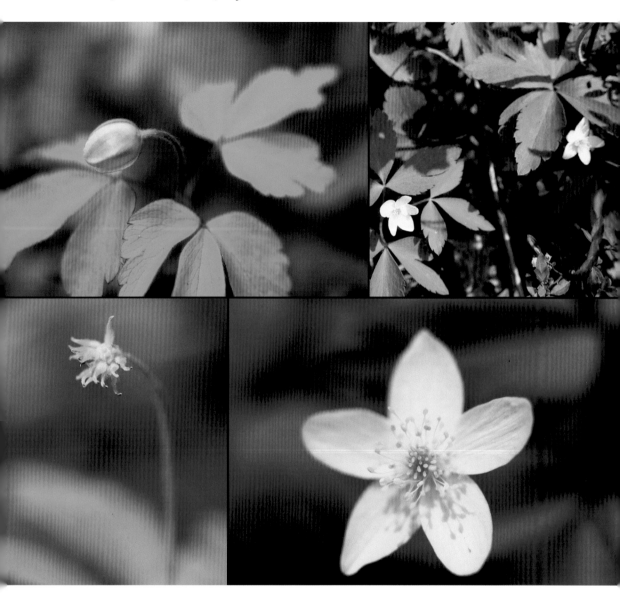

THE ANEMONE WAS NAMED after the Greek god of the winds, Anemos, which may explain another of its common names: windflower. The plant spreads by rhizomes (horizontal underground stems), producing, with time, a patch of white blossoms. The wind plays an important role in the anemone's life cycle, blowing pollen to nearby blossoms and fertilizing them without the help of insects, which are scarce in the early spring. American Indians have used a tea of anemone roots to treat headache and dizziness—some believed it could even refocus crossed eyes.

BLUEBERRY ℬ

Vaccinium angustifolium, Vaccinium myrtilloides

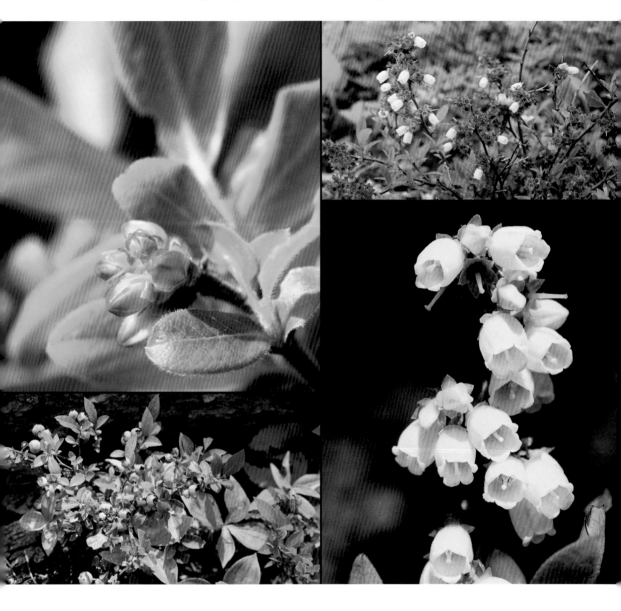

THERE ARE TWO SPECIES OF BLUEBERRIES in the Boundary Waters region: the *myrtilloides* has soft, fuzzy leaves, and the *angustifolium* has smooth, shiny leaves. The blueberry's white bell blossoms are a good predictor of how many pies or jars of jam will be enjoyed that year. Of course, a few good rain showers just as the berries are filling out are also essential. After the white bells disappear, they are quickly replaced with bright red stars. Red stars, white flowers, and blue berries make this plant quite patriotic, and if you are *very* lucky, you might even find a ripe berry on the Fourth of July. More likely, it will be later that month, as blueberries usually ripen toward the end of July.

SMOOTH ROCK CRESS ℘
Arabis laevigata

EVEN THOUGH ITS FLOWERS ARE SMALL, the rock cress towers above other vegetation and seems to be calling, "Hey, look at me." A solitary plant blooming with its small blossoms atop a tall stalk is not terribly impressive, but the delicate lavender blossoms, reminiscent of an opal gemstone, will get your attention when you see twenty to thirty rock cress blooming in one area. Rock cress thrives in gravelly areas: look for it along the roadside. Gazing down on a rock cress plant in its final fruiting stage, you will view a deep mauve color. But if you were a beetle looking up at the seedpods from the ground, you would discover that their undersides are lime green. Children might use this color-change "trick" in their next magic show.

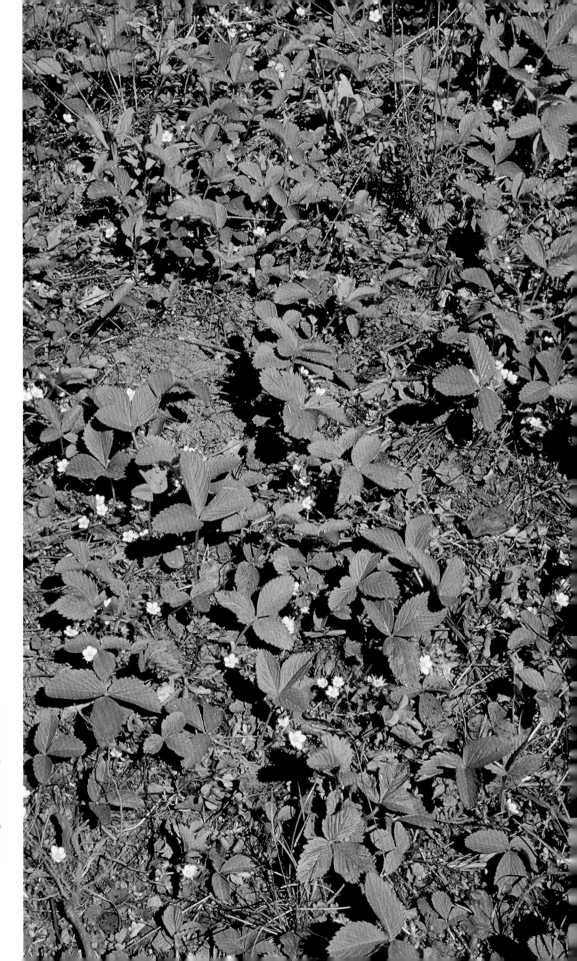

COMMON STRAWBERRY ॐ

Fragaria virginiana

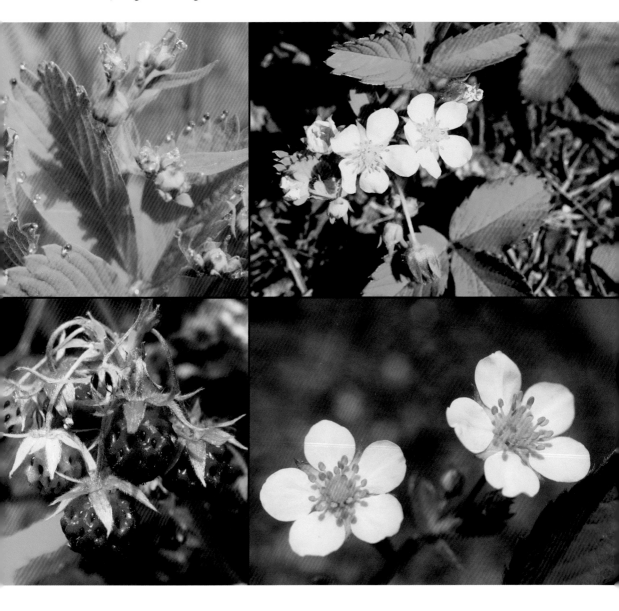

NOTHING TASTES BETTER or has more flavor for its size than the wild strawberry. Izaak Walton agreed with this sentiment, saying, "Doubtless God could have made a better berry, but doubtless God never did." The fruit is small, averaging a mere one-half inch. Some of my north woods neighbors tell of picking enough to make jam: they have more patience and a stronger back than I. If you're wondering why you have so few ripe strawberries on your plants, probably the chipmunks got to your strawberry patch before you did. They have a definite advantage, coming face to face with the sweet morsels as they scurry around under the leaves.

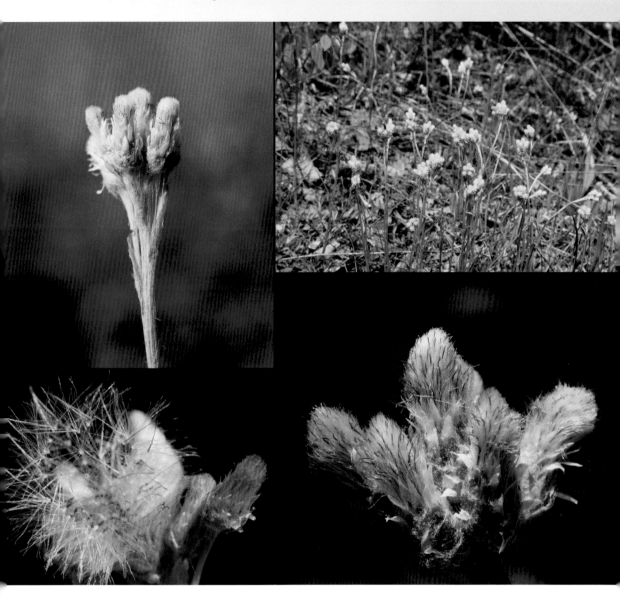

PUSSYTOES ARE A FAVORITE with young children because they can readily see and feel the connection with a cat's paw. Children might like the pussytoes, but adults try to eradicate them, especially if they have invaded a "picture-perfect" yard of green grass. Pussytoes might stand a chance even in a metropolitan area today as people reduce the amount of chemicals applied to their lawns. In fact, pussytoes do a little poisoning of their own. They give off chemicals in the soil that other plants can't tolerate, thereby killing their competition for sunlight and moisture. Male and female flowers are on separate plants; the female flowers are usually larger and have a brighter pink hue.

Early-season Flowers

NODDING TRILLIUM ❧

Trillium cernuum

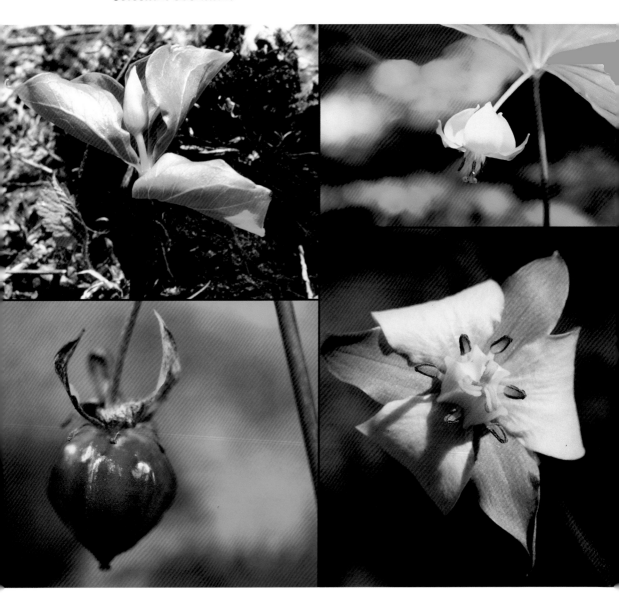

IF A WILDFLOWER TREASURE HUNT asks for a "red jewel," the trillium's seed capsule would certainly qualify. Its coloring can only be compared to red metallic enamel, like that seen on a luxury automobile. If you think this an exaggeration, hold a seed capsule in your hand in bright sunlight, and you'll question no longer. The name *trillium* suggests threes, and, indeed, the blossom has three white petals and three green sepals (leaflike parts growing below the petals). The single flower with upturned petals hangs like a pendant below the three large leaves, exposing itself to only the sharpest-eyed wildflower hunters. The full flower image above was possible because I picked one blossom that was growing by my woodshed, photographing it so you could marvel at the designs on its underside. Notice the handsome pistil growing in the flower's center.

FALSE LILY OF THE VALLEY ✿

Maianthemum canadense

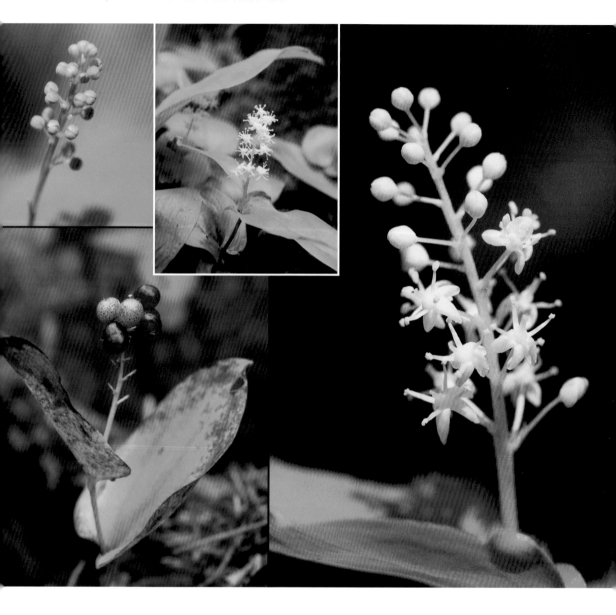

IF YOU NOTICE a number of single, shiny, heart-shaped, smooth leaves growing in a patch, you probably are looking at the beginning of a false lily of the valley colony. Eventually these plants will mature into two- or three-leaf stems with a spike of white flowers. Later in the season, their fruit changes from green, to red speckled, to a translucent bright red, soon becoming dinner for chipmunks, mice, and other little critters. The leaves are angled in opposite directions to better catch a ray of sunshine through the long-shadowed forest canopy. The genus name, *Maianthemum*, means "May flower." But guess what—it has never bloomed in May at my cabin.

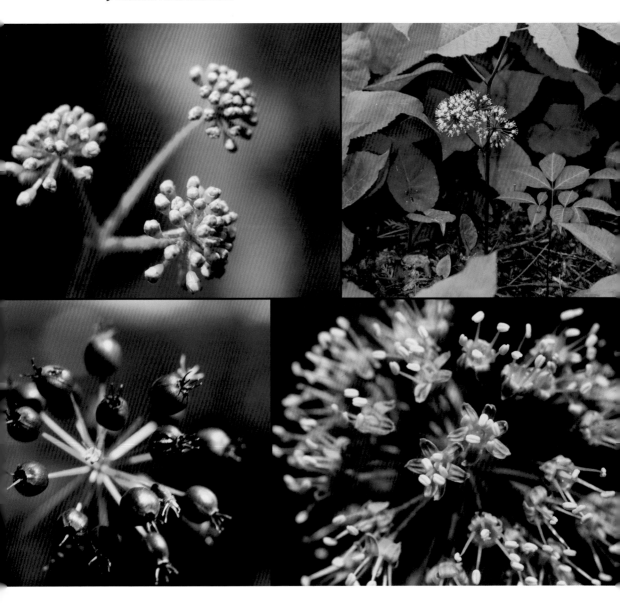

THE WILD SARSAPARILLA seems to enjoy playing a bit of magic in the early spring. Its foliage emerges from the ground with a deep burgundy color and doesn't change to green until it's about twelve inches tall. The leafless flowering stalk produces three round, ball-like clusters of small white flowers. Its leaves form a canopy over the blossoms so that sometimes you can be looking down at them and not realize the plant is blooming. The story goes that the root of this plant was used to make root beer—perhaps only if sarsaparilla, *Smilax officinalis*, the preferred plant for flavoring, was not available.

LABRADOR TEA ✿

Rhododendron groenlandicum

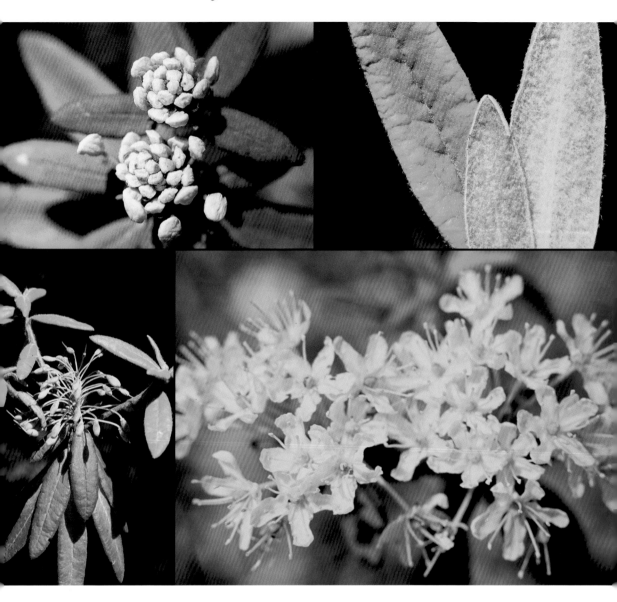

THE LEAVES OF THIS SHRUB might win the contest for having the most unusual properties. The leaf texture on top is like a soft, high-quality leather, the edges roll under like a fine seam, and the color is a rich emerald green. The underside is a soft, white, wool-like mat that changes color to a rich orange brown as the leaves mature. Three arranged leaves (above) illustrate these facts. Still later in the season, as the seeds are maturing, the topmost leaves turn a brilliant red. When Labrador tea blooms in late spring, its white flowers carpet many bog areas. Who could ask for anything more?

RED BANEBERRY

Actaea rubra

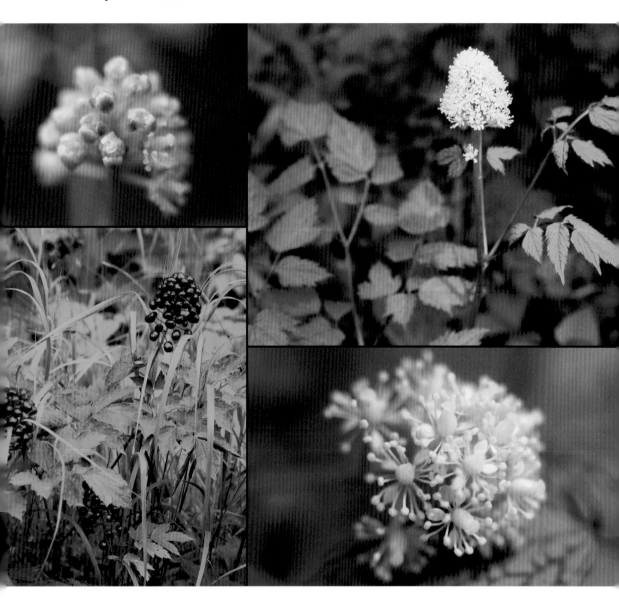

THERE ARE TWO COMMON VARIETIES of baneberries—one red and the other white. Both red and white berries are temptingly beautiful, but beware: they and their root-stalks are poisonous to humans. Small creatures and some birds do find the berries to their liking, with no adverse side effects.

The compound leaves have many sharply toothed leaflets, and they surround a rather ordinary cluster of small, white flowers. Here is a plant whose fruit is more impressive than its blossom. American Indians have used white baneberries to treat diseases of women and red baneberries for diseases of men.

STARFLOWER ∽

Trientalis borealis

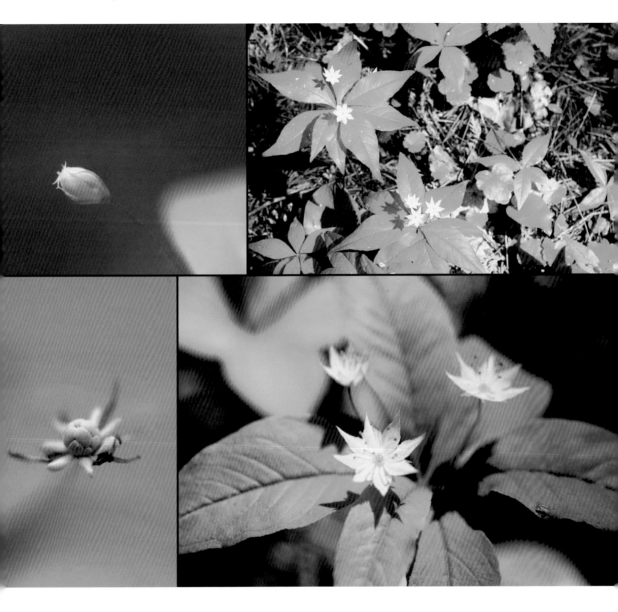

IF YOU'RE LOOKING for the sharpest-pointed stars on the forest floor, the starflower might be your choice. Many times only one blossom rises above a whorl of lance-shaped leaves. However, in ideal growing conditions, three blossoms are not unusual. Many wildflower books tell you that this plant is a study in sevens: seven sepals, seven petals, seven sta-mens. But wait, check the photo: the camera never lies. I count eight petals, don't you? Exceptions to all rules exist, even in the world of wildflowers. The starflower's seedpod is a bit of a surprise: under magnification, it appears to be a small soccer ball, just waiting for action.

GOLDTHREAD ℬ

Coptis trifolia

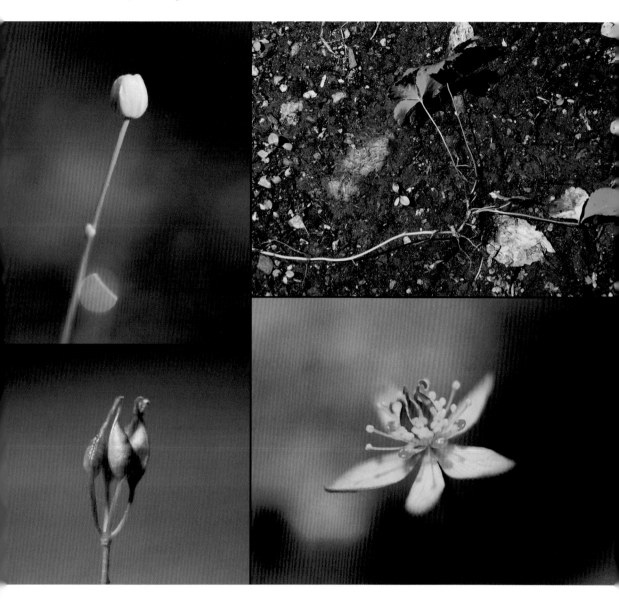

USUALLY EACH PLANT'S COMMON NAMES are quite descriptive of the flower or fruit. Not so with the goldthread. Unless you dig up a goldthread, you'll be left to wonder where its name came from: its root is a golden thread. Once you've seen its rhizomes, you will enjoy viewing its small, shiny green leaves on the forest floor, knowing that its gold is hidden underground. In the past, its gold was valuable and in demand because goldthread roots were used to treat sore eyes, earning a listing in "American Medicinal Plants of Commercial Importance" until 1930.

BUNCHBERRY ✿
Cornus canadensis

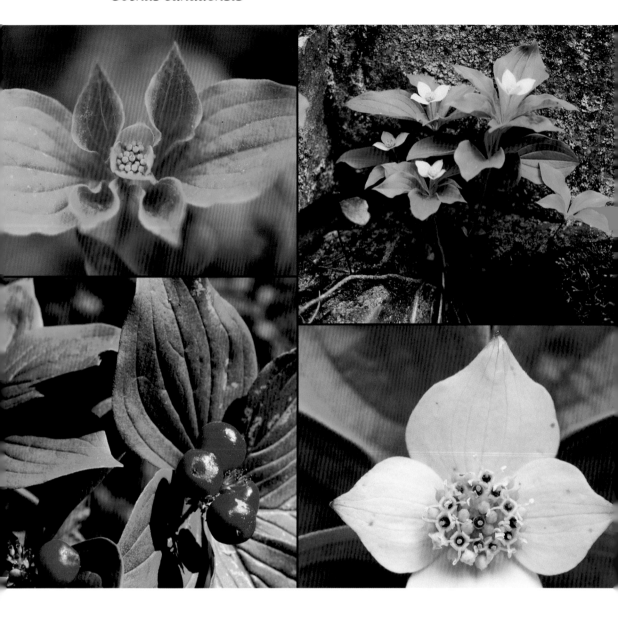

THE BUNCHBERRY FOOLS MANY PEOPLE into thinking they are looking at a beautiful, white, four-petaled flower, but the white "petals" are actually sepals. (Sepals are usually a ring of smaller, generally green leaves below the petals. However, in some plants, the sepals are large and may even be colored.) The cluster in the center of the white sepals is where the bunchberry's flowers are found. The im-

pressive light green buds nestle in the center of six symmetrical, darker green leaves. The bunchberry stands only three to six inches tall and produces blazing red berries. These attention-getters are especially attractive when found growing with bluebead lilies in the fall. Bunchberries spread by underground rhizomes, forming a dense carpet on the forest floor.

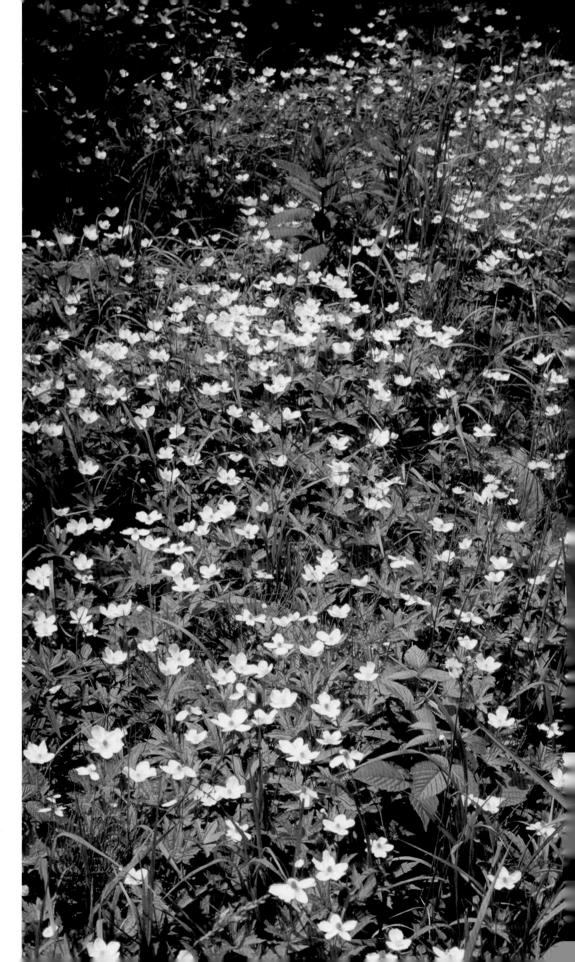

CANADA ANEMONE ℬ

Anemone canadensis

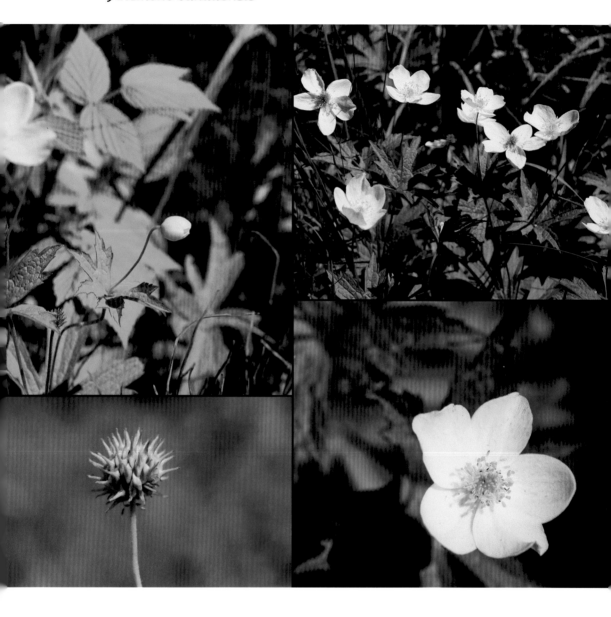

THE CANADA ANEMONE blooms in early summer, unlike the spring-blooming wood anemone. The first time I saw Canada anemones blooming, they were in a wet roadside ditch in full sun. Because the blossoms resemble the wood anemone, which is most often seen in shady, open woods, I was a bit confused, but when I noticed the coarsely toothed, deeply lobed leaves, I realized I was looking at a different species, one of about twenty-five anemones in North America. American Indians have used the root for medicinal purposes: clearing up lung congestion and burning the seeds to revive unconscious persons with the smoke. They refer to this and other members of the buttercup family as *crowfoot*. A keen imagination reveals that the leaf resembles its namesake.

Early-season Flowers

CARAWAY 🌿

Carum carvi

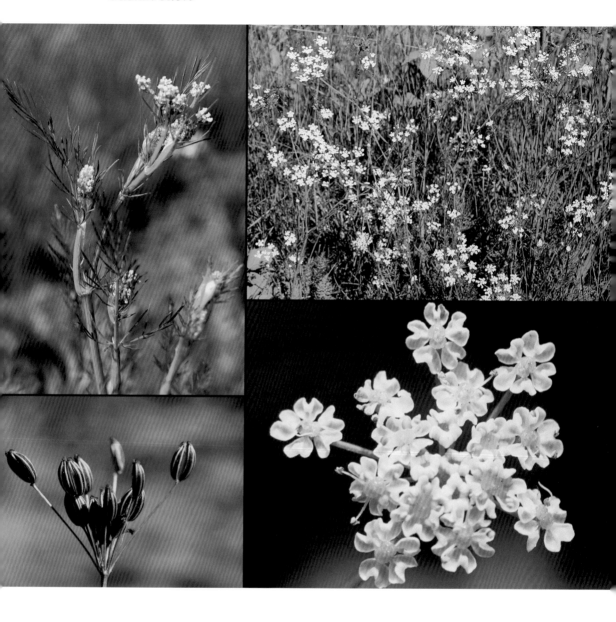

IF YOU HAVE CONFUSED CARAWAY with Queen Anne's lace, you are not alone. The mistake is seldom made during the fruiting season, when Queen Anne's lace forms its signature shape of a bird's nest made of stems and seeds. Caraway's fruiting stage (above, bottom left) involves an umbral shape, with each flower's stalk rising from a common center, just as when it was blooming. The easily recognizable seeds are a good reminder to begin planning to make your next batch of rye bread. Crush a few between your fingers, smell them, and you will be certain of this plant's identification.

PALE VETCHLING
Lathyrus ochroleucus

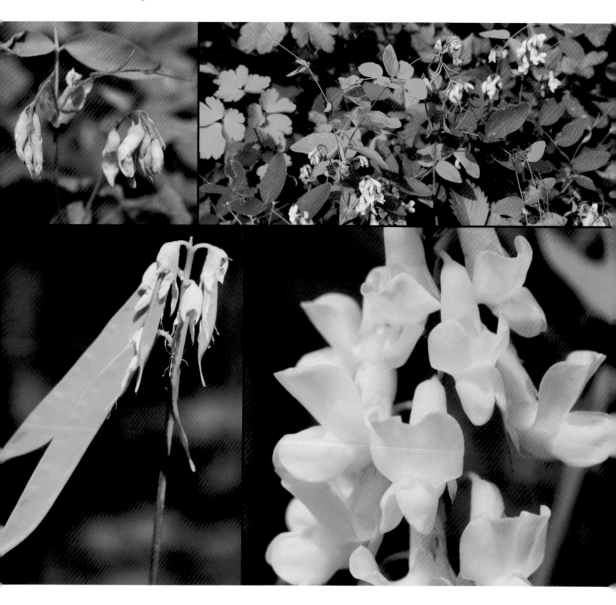

THE PALE VETCHLING resembles a white- or cream-colored sweet pea growing in your garden, but it produces multiple bonnet-shaped flowers arranged in flat clusters on the flowering stem. This plant has compound leaves (a central stalk with two or more leaflets) and tendrils at the terminal of the leaf stalk. After you have met one member of the pea or bean family, you will soon recognize its cousins. They like to wear different colors—white, pink, violet, purple—but their "bones"—leaves and stems—are similar.

ONE-FLOWERED WINTERGREEN

Moneses uniflora

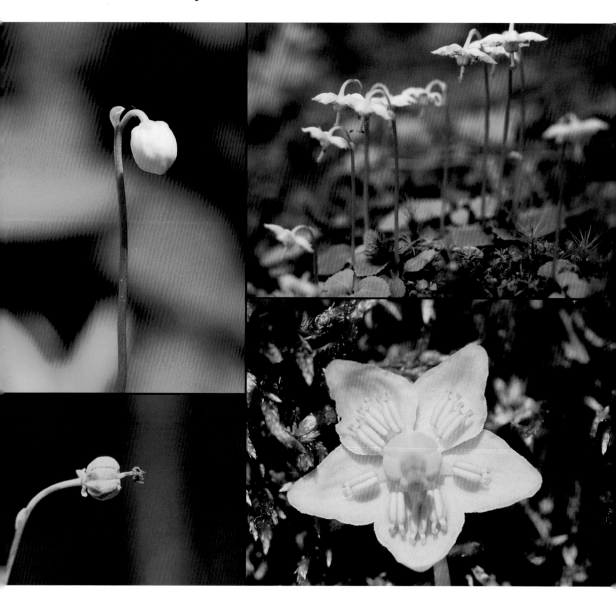

THE FIVE-POINTED STAR appears again and again in different seasons of many wildflowers: I sometimes think there are as many stars on the ground as in the heavens. No wildflower stars are so pure and perfect as that of the one-flowered wintergreen in full bloom. If you come upon a patch of them when the light is just right, you might think the sky is falling. What a heavenly experience to have stars scattered at your feet. This plant's maximum height is about four inches. For comparison, take a look at the mature flower of the pipsissewa and notice the similarities of both pistils and stamens.

CALYPSO ORCHID ❧

Calypso bulbosa

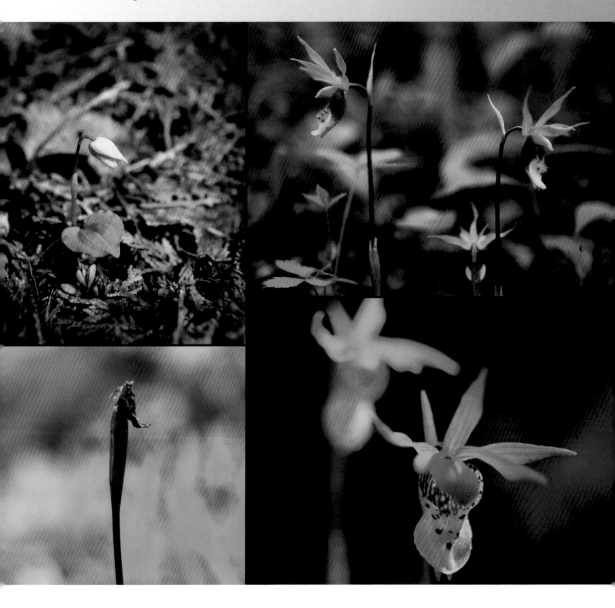

ONE REASON wildflower enthusiasts plan a trip to northern Minnesota early in the springtime is the possibility of finding the rare calypso orchid in bloom. Many consider it a solitary plant: imagine my astonishment when Mother Nature presented a bouquet of calypsos only four feet off my cabin drive. An even bigger challenge than finding a blooming calypso is finding one in its bud or seed form. It has only one small, dark green basal leaf, one to one and a half inches long, which hugs the forest floor. Begin your search in the proper habitat: for the calypso, in cool, damp, mossy, coniferous woods. The blossom appears on a three-inch leafless stem, its petals twisting and turning in the wind like ribbon confetti at a birthday party.

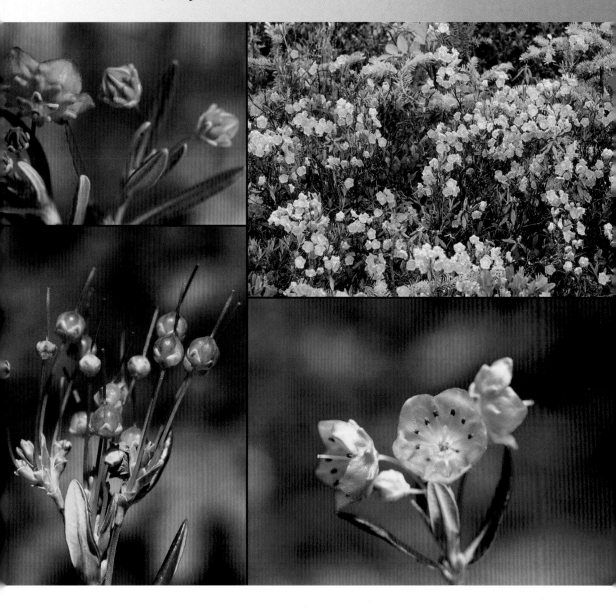

IF EVER YOU WERE PLANNING a wedding in a bog, you'd want to schedule it when the bog laurel is in full bloom. Mother Nature usually endows this shrub with an ample supply of showy, intense pink blossoms. Look carefully at a single blossom: you will be rewarded with seeing a most interesting corolla (the circle of the flower's parts, made up of petals).

The backside of the blossom continues to amaze. The bog laurel should win an award for having the most unique bud of all my wildflower friends—look closely at the ribbed turban shape. Let's hope the wedding guests realize this plant's toxicity, though: ingestion could lead to slowed pulse and progressive paralysis, and possibly even death.

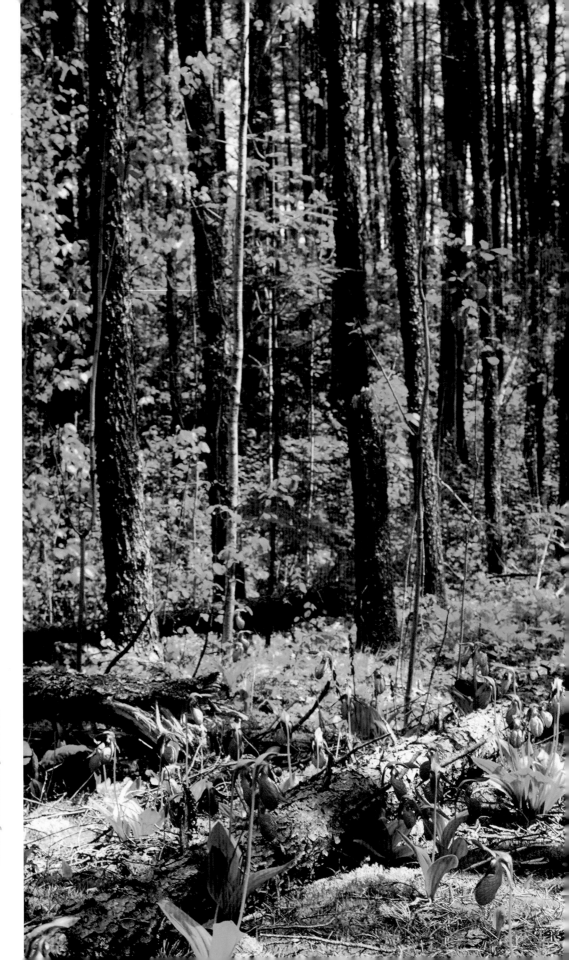

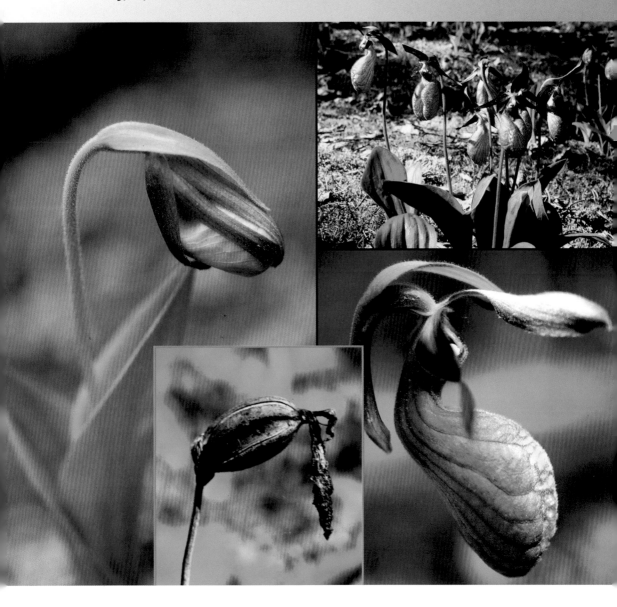

FINDING A FIELD OF PINK LADY'S SLIPPERS in bloom is always a thrill. Also known as moccasins, they thrive under tall jack pines, sharing their environment with reindeer moss, wintergreen, pipsissewa, and other plants that can survive on filtered light. Insects have a difficult time entering the moccasin's blossom in order to reach its sweet nectar. Once inside, they find it next to impossible to escape, sometimes having to eat their way out.

It takes many years—some say twelve to fifteen—from the time a seed leaves the capsule until a new flower appears. The lady's slipper seed is unusual in that it has no food reserves: the tiny seed must be penetrated by fungus threads on the forest floor in order to receive its nutrition. This requirement no doubt explains its extremely low germination rate, reason enough to feel grateful when you see a moccasin in bloom.

BICKNELL'S CRANESBILL ❧

Geranium bicknellii

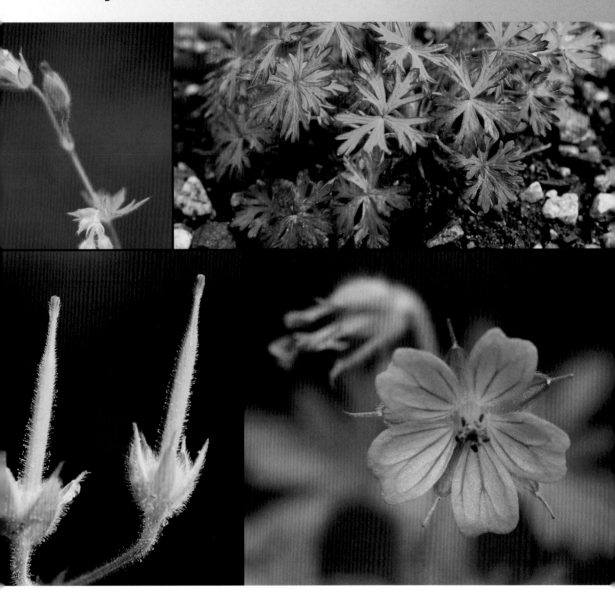

IT WAS DIFFICULT TO DECIDE which stage of the seed development of *Geranium bicknellii* to show you. The stage that reflects the common name *cranesbill* won out: it's quite obvious that the seed capsule's long, narrow shape resembles the bill of a crane. It's worth a return visit to this plant in a few days to see the seedpod split into segments that curl upward. The small pink blossom is easy to overlook; it definitely doesn't draw attention to itself. When you do see it, take a minute to appreciate the deeply cut, lobed leaves. It's one of our native wildflowers and deserves more attention than is usually given it.

ROSE TWISTED STALK ✌

Streptopus lanceolatus

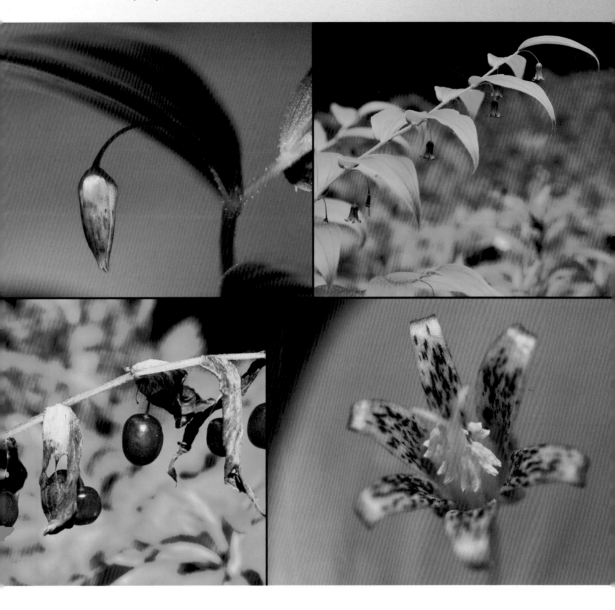

MANY GOOD BOOKS have been written about wildflower folklore. One explains another common name for rose twisted stalk: scootberry. An oft-repeated story goes that some boys ate the berries, which acted as a physic. Since diarrhea was referred to as "the scoots," the plant was given the name scootberry! The origin of the common name *twisted stalk* is obvious: the stem zigzags from side to side and changes directions at each leaf juncture. The flower in full bloom boasts a mottled rose coloring.

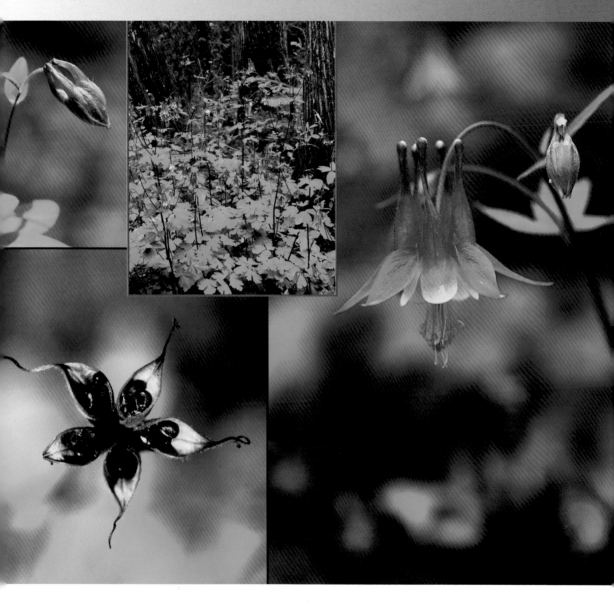

COLUMBINE AND HUMMINGBIRDS are quite a team: if you plant columbine, hummingbirds will come. Hummingbirds are the only creatures that can easily sip nectar from the long, vertical spurs and, in the process, pollinate the plant. Columbine may have earned its genus name, *Aquilegia,* Latin for "eagle," because the spurs resemble an eagle's talons. At one time the columbine was suggested as the United States' floral emblem because of this botanical connection to the national bird. Others say its common name *columbine,* Latin *columba* for "dove," reflects its resemblance to a circle of doves. Its glossy black seeds presented handsomely in a floral shape are no doubt attractive to a small bird looking for an energy snack.

PALE CORYDALIS ✂

Corydalis sempervirens

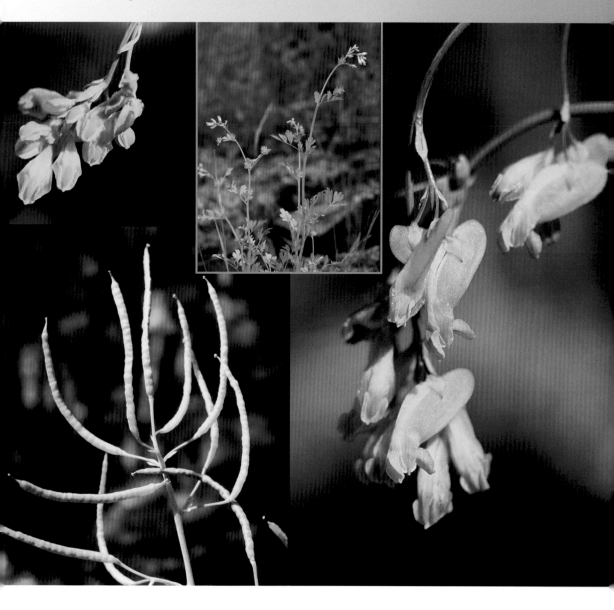

THE FIRST CHARACTERISTIC of the pale cory-
dalis to catch my eye is its silvery, blue green
leaves. The fragile-looking, saclike flowers
include a spur arising from one of four petals.
Corydalis is Greek for "crested lark," and a look
at the blossom will explain the name. Another
unique feature is its flower, made up of two
distinct colors: a bright pink and a bright yel-
low. Its sister plant, the golden corydalis, is
similar but boasts all yellow blossoms and
blooms earlier in the season.

PRICKLY WILD ROSE

Rosa acicularis

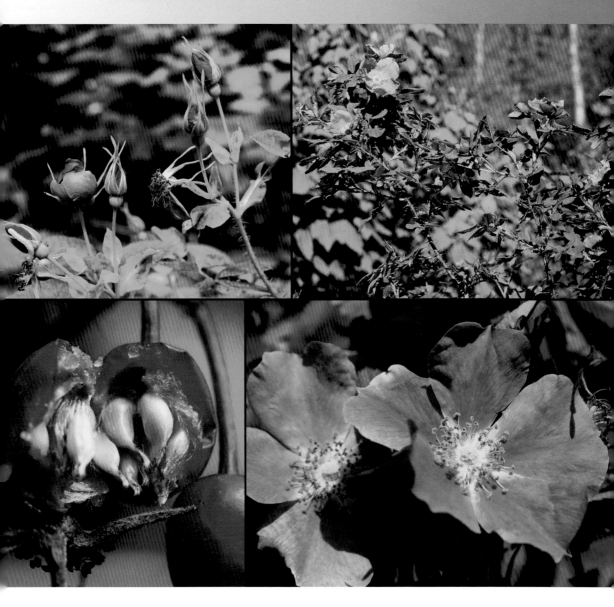

MOST PEOPLE ARE THRILLED to receive roses on special occasions, but it's always a special occasion when you see roses blooming in the wild. The cultivated rose and the wild rose do not have a lot in common, but there are some similarities. The wild rose's fragrance is just as sweet, it displays as much beauty with five petals as does a hybrid rose with many more, and its prickles are as prickly. *Canoe Country Flora* tells us that roses do not have thorns: "Thorns are actually modified branches arising in the axils of leaves while prickles are slender, sharp-pointed outgrowths of the bark." I am especially fond of wild roses because I was born in Roseland, Minnesota, a small town whose name honors the flowers that were abundant when immigrants settled there.

TWINFLOWER ❃

Linnaea borealis

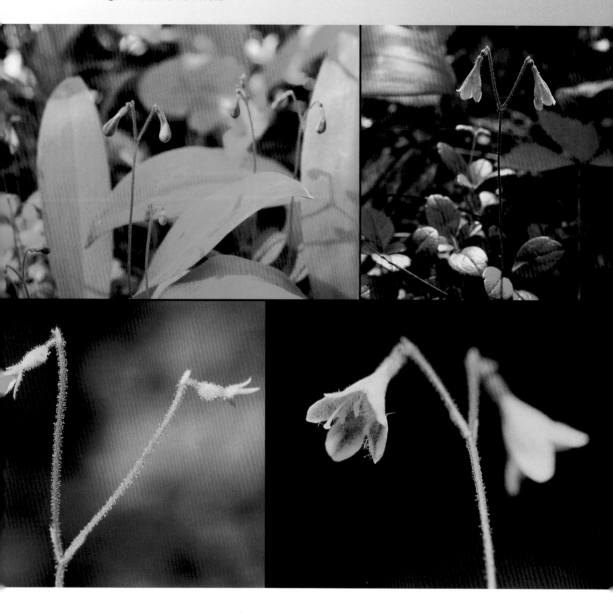

WHY WOULD LINNAEUS, the Swedish botanist who developed the way we name plants and animals—using two names: the genus and species—choose the tiny twinflower to carry his name? He thought the flower much like himself: "lowly, insignificant, and flowering for a brief space." While the twinflower appears demure, delicate, and perhaps a bit shy, Linnaeus also showed opposite characteristics: some considered him to be brash and arrogant. Regardless, we are forever thankful that his nomenclature system—every plant awarded its own scientific name used the world over—has made order out of chaos for more than two hundred years.

MARSH MARIGOLD ✿
Caltha palustris

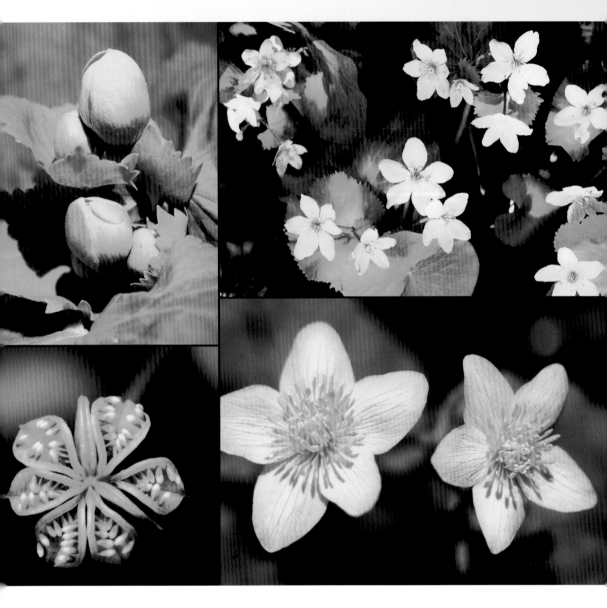

YOU WILL KNOW THAT WINTER IS OVER when you see the marsh marigolds silently waiting, hoping to be noticed on your morning walk. Sometimes the first small green leaves are cradled in the last crystals of snow. As the name suggests, they will be found in marshy areas, growing at water's edge. This plant teases with its magnificent, bulging buds as you wait for it to burst forth in bright golden glory, so welcome after a long, cold winter. The large emerald, saucerlike leaves provide a backdrop for the nosegay of blossoms. At the end of its blooming season it surprises once more, as its seeds are presented in the shape of a flower.

DOWNY YELLOW VIOLET 🅑

Viola pubescens

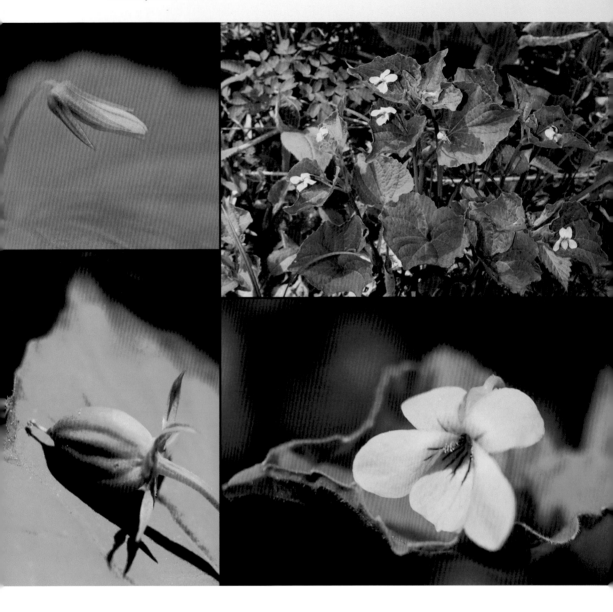

THE DOWNY YELLOW VIOLET, while not seen as often as the common blue violet, is just as beautiful. There are more than seventy-five violet species in North America and many more worldwide. Violets are pollinated mostly by bees, but ants also play an important role in the life cycles of some species. They carry the ripened seed off to their nests—sometimes quite a distance away—and store them in unused tunnels. There the seeds have a better chance of germination than those left on the forest floor. The yellow violet develops on the top of an eight- to twelve-inch stem: it's hardly a "shrinking violet."

WINTER CRESS ❧

Barbarea orthoceras

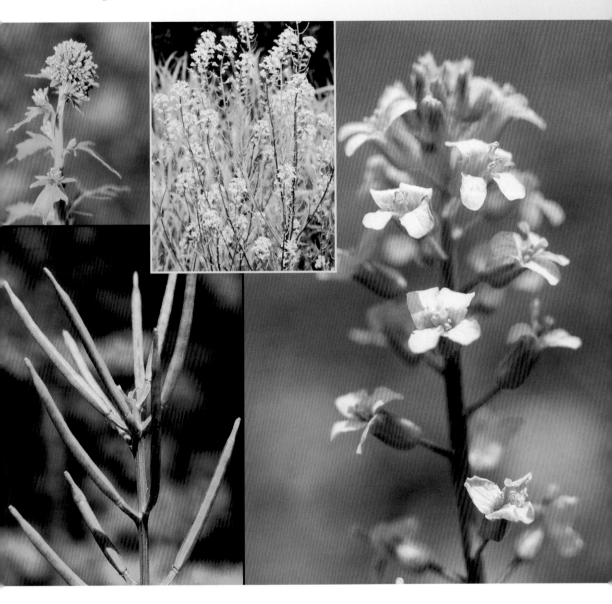

THE WINTER CRESS is a member of the mustard family. And in *my* family, mustard didn't have a very good reputation. It was not a friend of the farmer (or me) when I was growing up, before the widespread use of herbicides. I had to take hoe in hand on hot summer days and go out in the fields to destroy as many of the yellow flowers as I could. Now I eagerly await the blooming of winter cress, and I have even helped it along by distributing a few of its seeds to my garden.

(My farmer father would never have believed this.) Members of the mustard family are determined to survive: seeds have been known to sprout and grow after lying dormant for forty years. Does this detail enhance the meaning of "faith like a grain of mustard seed"? When I was a child, a charm to be worn as a necklace or on a bracelet held one mustard seed in its center, a constant reminder of this familiar verse.

BLUEBEAD LILY ❀
Clintonia borealis

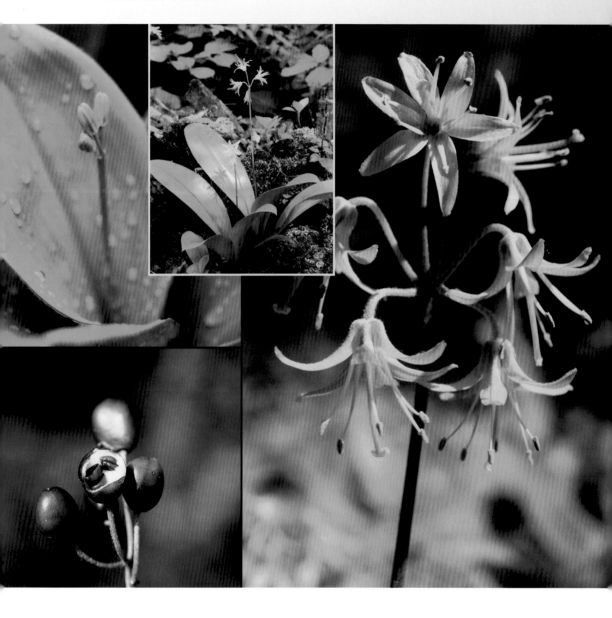

IN EARLY SPRINGTIME, the bluebead lily's foliage—two lance-shaped, toothless, five-to eight-inch-long leaves—fools some wild-flower hunters into thinking they have found the leaves of a lady's slipper orchid. The easi-est way to distinguish between the two is that the bluebead leaves are thicker and fleshier, and the lady's slipper leaves have more pronounced veining. In fall, the blue-bead lily's fruit has been mistaken for blue-berries. The main visual difference between the two is that the bluebead is positioned on a long, slender stalk resembling a cande-labra. Do not eat any blue berry you cannot identify: the bluebead lily's fruit is poisonous. Some refer to the blue color as "true blue," but I suspect other color aficionados prefer the term *indigo*.

COMMON BUTTERCUP

Ranunculus acris

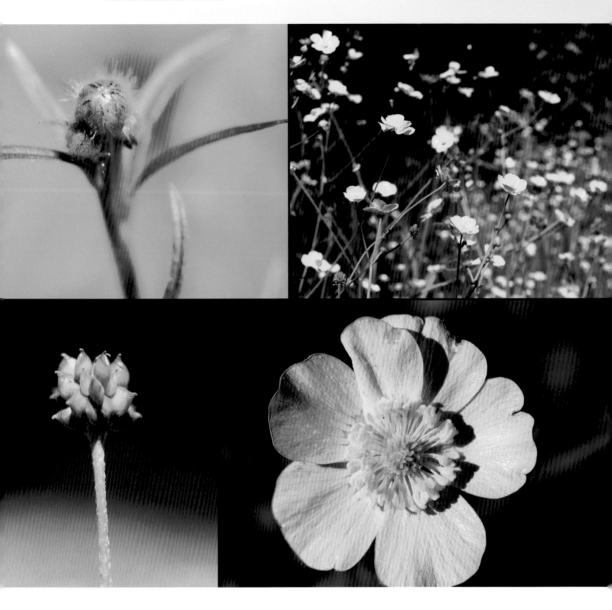

NOTHING IS A BETTER ANTIDOTE for a cloudy day than a patch of buttercups, whose blossoms impart a warm glow that can raise your spirits. It was once thought that buttercups in the pasture meant golden butter on the table, as other common names suggest: butter cresses, butter daisy, butter rose, and butter-flower. In reality, cows avoid these plants, which tend to make their milk bitter and unpalatable. Indeed, the juice of a buttercup can raise a blister on your skin: beggars have been known to use this trick to gain sympathy when asking for a handout. An old legend states that one day while serenading wood nymphs, the young boy Ranunculus, known for his melodious voice and brilliant dress, became so enamored with his singing that he expired in ecstasy and turned into a buttercup.

ROUGH CINQUEFOIL 🖉

Potentilla norvegica

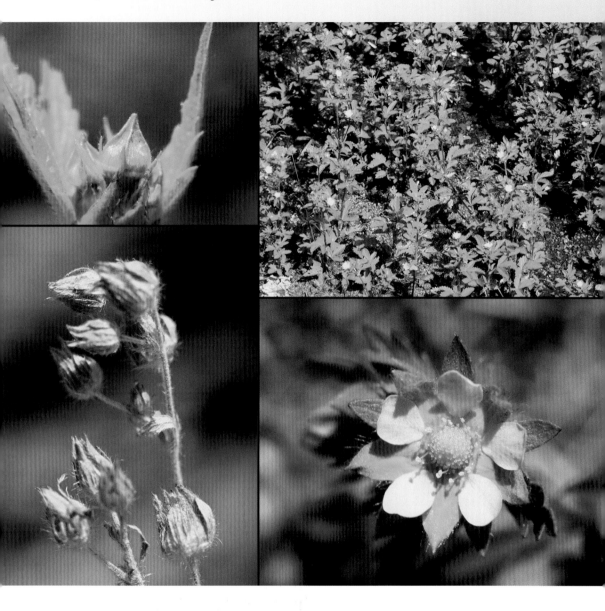

THE CINQUEFOILS ARE COMING! As more of our topsoil is lost to "development," look for the invasion of the cinquefoil, which can thrive on harsh, barren soils. A cinquefoil species creeps into areas where nasty substances, such as oil, salt, or gasoline, have been dumped. Cinquefoil means "five-leaved," but rough cinquefoil has three coarsely toothed leaflets (a leaflike part of a compound leaf). Some potentilla cousins are popular shrubs available at your local nursery. They bloom all summer long, making a lovely addition to your home landscape.

MITERWORT ♋

Mitella nuda

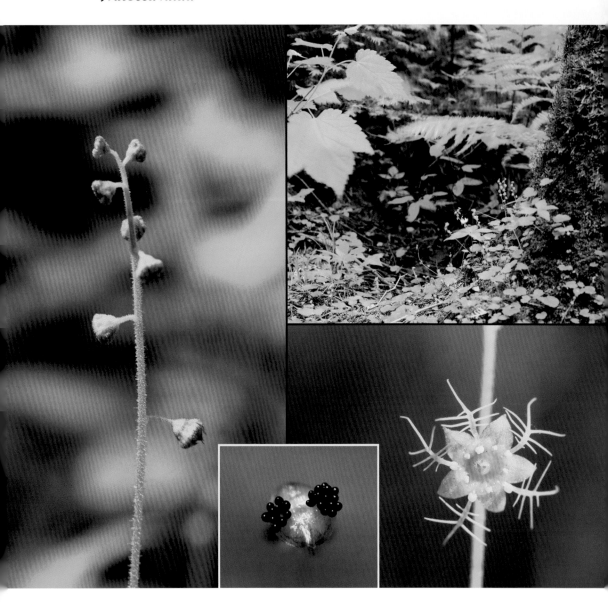

IF YOU BELIEVE IN FAIRIES, you might imagine the miterwort to be one of their favorite flowers. Though small in stature—I've never seen one more than five inches tall—the flowers are spectacular. What appears to be the petals of one of nature's five-pointed starflowers is really a star made up of sepals: the five lacy, spider web–like threads are the true flower petals. On *Mitella nuda* (above, bottom center), the common name *bishop's cap* refers to the shape of the seedpod. On another miterwort species, *Mitella diphylla*, the common name refers to the shape of the flower.

COMMON BLUE VIOLET ℬ
Viola sororia

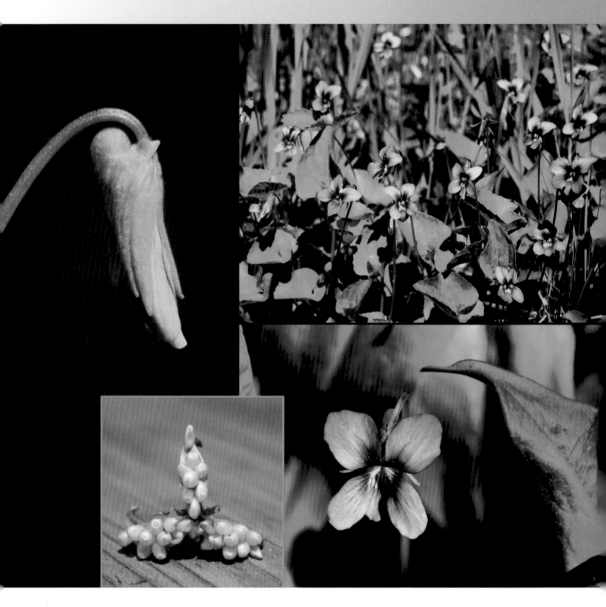

IN NORTHERN MINNESOTA, this violet is known by two names: common blue or woolly blue. It has hairy basal leaves but no leaves on its flowering stems. If growing conditions are favorable, this violet is prolific: I've seen patches containing several thousand in bloom. If you have a large patch near your cabin, this is the flower you should gather to make candied violets for use on a special confection. It's easy: simply dip the blossom in beaten egg white and then into finely granulated sugar, arrange carefully on a plate, dry, and enjoy. Freeze some for a surprise dessert garnish on a cold, snowy winter day.

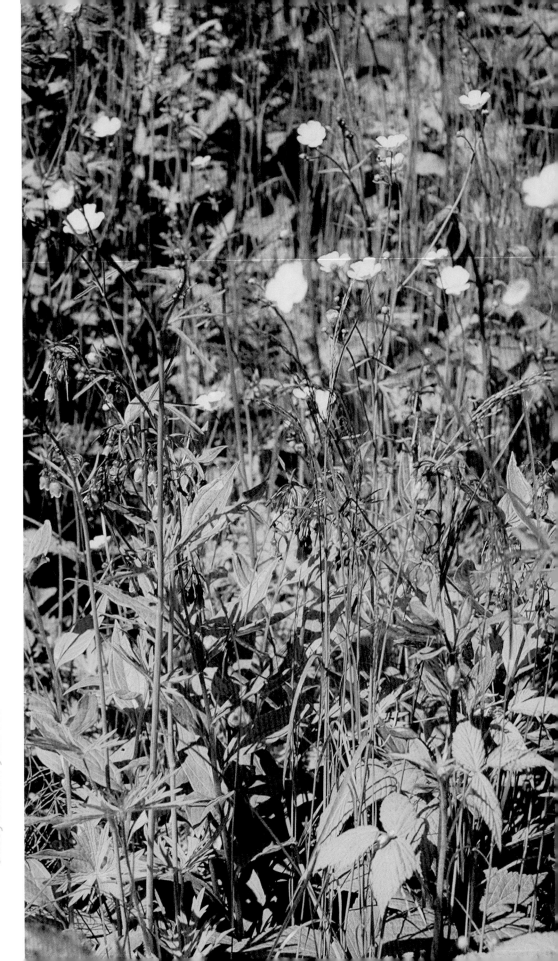

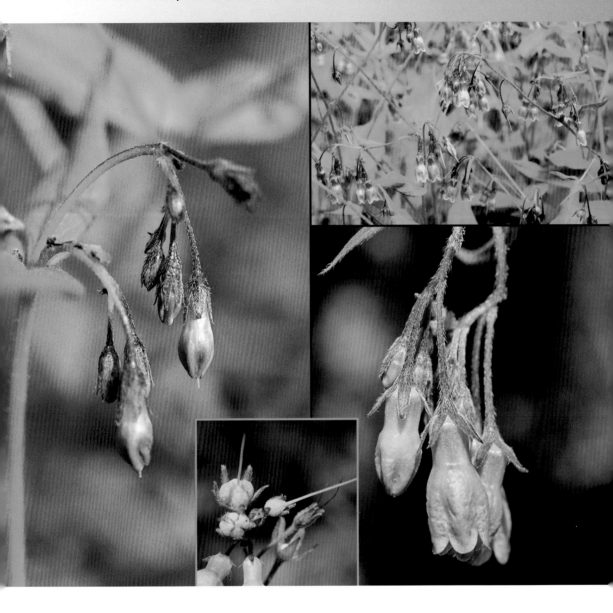

IF YOU SAW ONLY THE PINK BUD of the northern bluebell early in its flowering season, you would anticipate a pink blossom. However, as the bud matures, it expands into an elongated goblet or urn shape, and its hue becomes a light to medium blue when fully open. The flowers develop in drooping clusters on rather weak stems, and the leaves are alternate, lanceolate (lance-shaped), and slightly hairy on both sides. Lungwort is another common name for this plant: it was believed to be a remedy for lung disease. The Virginia bluebell *(Mertensia virginica)*, a close cousin, has a trumpet-shaped bell and blunt, hairless leaves .

FORGET-ME-NOT

Myosotis sylvatica

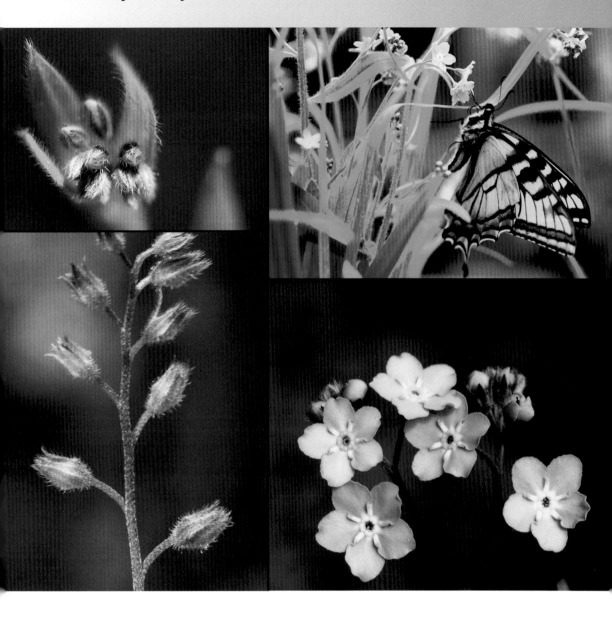

I CERTAINLY COULDN'T FORGET to include the forget-me-not, that diminutive, sky blue, five-petaled alien with the yellow eye. As you might expect, most stories about how the forget-me-not got its common name refer to friends or lovers giving the flower as a symbol of remembrance. Forget-me-nots are attractive in all kinds of weather. Do you think the photo on the left was taken with the early morning dew or at twilight after a refreshing spring rain? A white-flowered forget-me-not species may be the version Longfellow referred to in "Evangeline":

> Silently one by one, in the infinite meadows
> of heaven,
> Blossomed the lovely stars, the forget-me-
> nots of the angels.

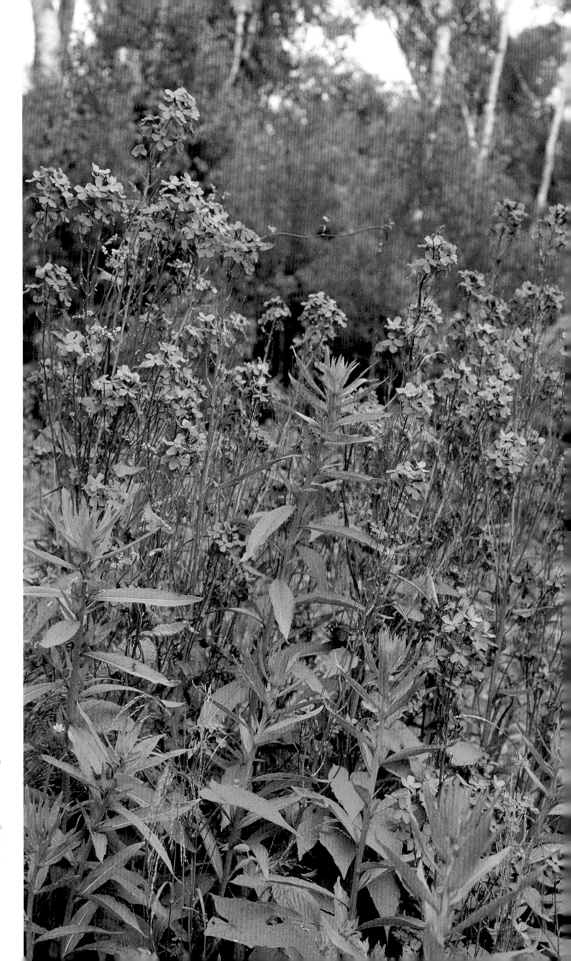

SWEET ROCKET

Hesperis matronalis

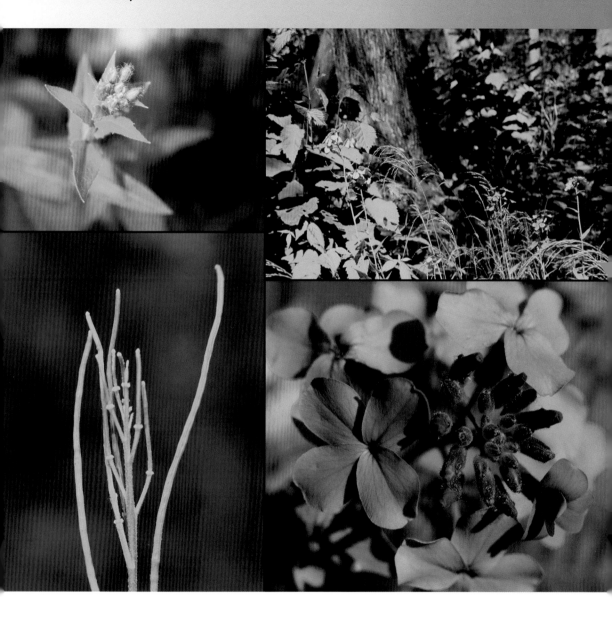

MY ASSOCIATION WITH THIS WILDFLOWER began as a child in the late 1930s. One of my earliest recollections of my mother's extensive flower garden was that for a few weeks each spring it seemed to be a mass of blue violet or blue purple flowers. She called the flower the *sweet rocket,* and I use that common name in her honor. Earlier wildflower books also use this name. *Dame's rocket* is the common name of choice. Sweet rocket is a member of the mustard family: you see the flower has four petals. Although lacking a noticeable fragrance during the day, these flowers make themselves known in the dark: use your nose as your guide. Sweet rocket was said to be a favorite flower of the women of Germany; they called it *dame's violet.*

BLUE FLAG

Iris versicolor

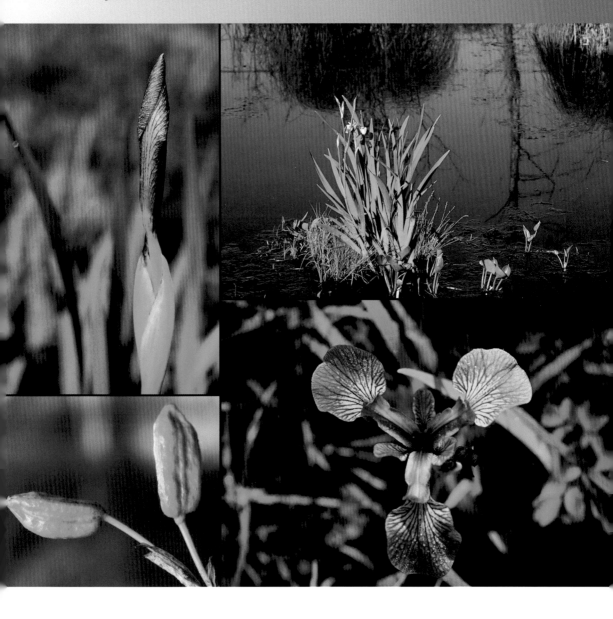

IT'S DIFFICULT TO FIND a more elegant wild-flower than the iris, named after the Greek goddess of the rainbow. The seedpod stands tall and proud, as does the blossom. Many stories explain the iris's historical connection with the kings of France. Most intriguing to me is one involving Clovis, an early monarch who lost battle after battle while his coat of arms included three toads. After his wife painted three irises on his shield, Clovis be-came a winner. This fact was not forgotten. Under the reign of Louis VII the iris symbol became known as the *fleur-de-Louis,* which later became the *fleur-de-lis* (even though *lis* means "lily").

MID-SEASON
FLOWERS

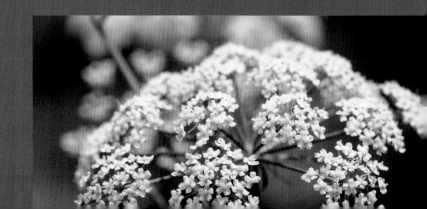

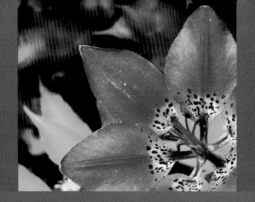

Strike up the band: the daisies are in full bloom, and

millions of northern wildflowers have joined the parade.

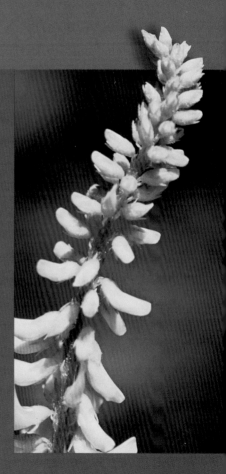

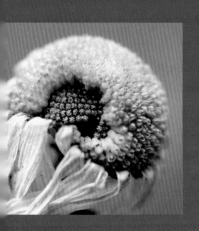

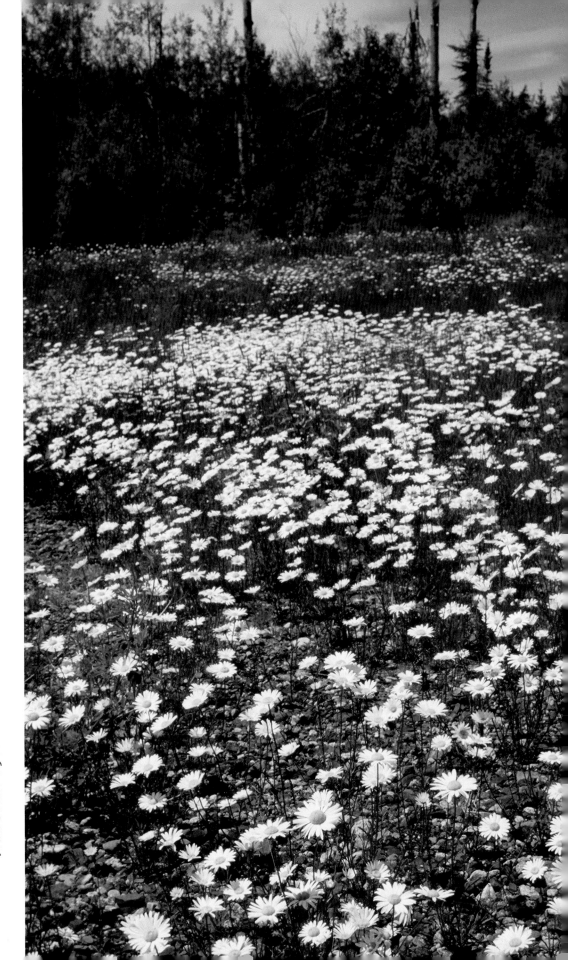

Mid-season Flowers

OX-EYE DAISY

Leucanthemum vulgare

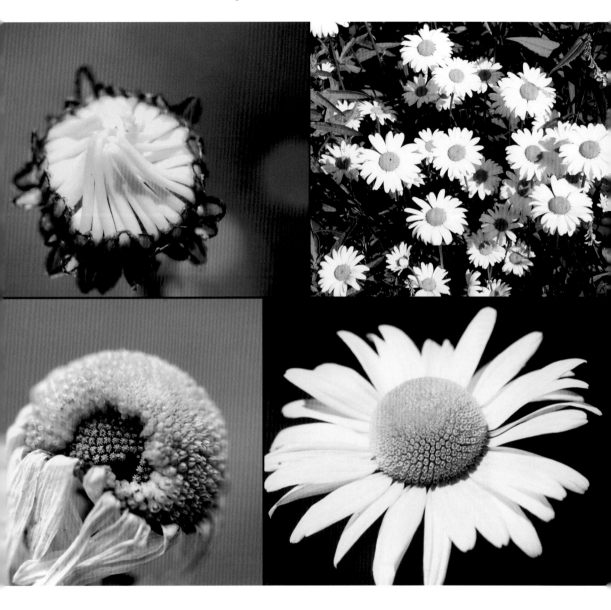

PROBABLY THE MOST FAMILIAR wildflower and one whose identity is never mistaken is the daisy. Hasn't everyone played "he loves me, he loves me not" or "she loves me, she loves me not"? Here's a secret: the daisy usually has an uneven number of petals, so the result of this game can be quite predictable. Though daisies are plentiful, a look at the intricate designs in the seed head will inspire a new appreciation for this marvelous creation. Daisy means "day's eye," implying that it blooms only during the daytime and probably closes up at night. While this is true of some species, the ox-eye daisy never closes its ray petals once it begins blooming. It's considered an invasive species: notice how it has crept into many photographs in this book.

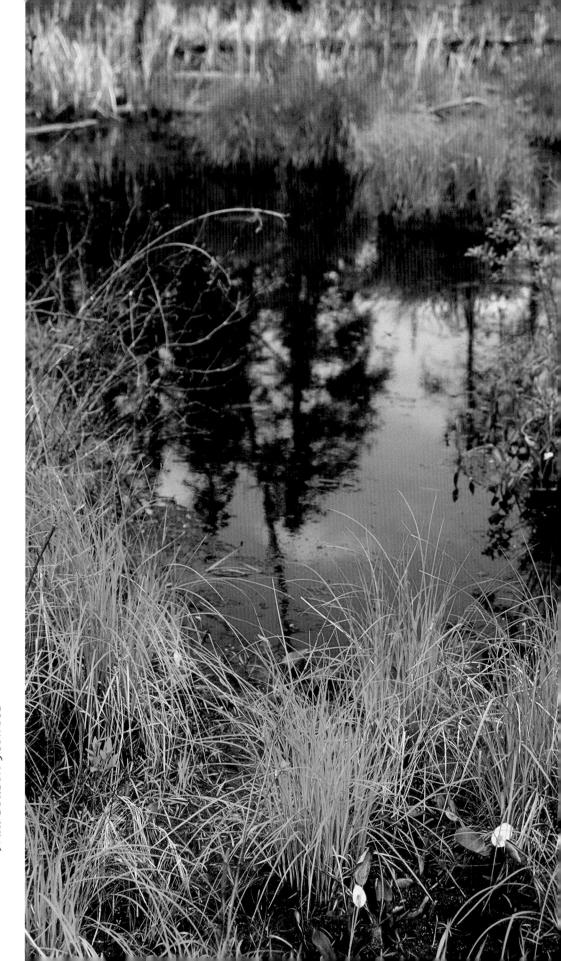

Mid-season Flowers

WILD CALLA ℬ
Calla palustris

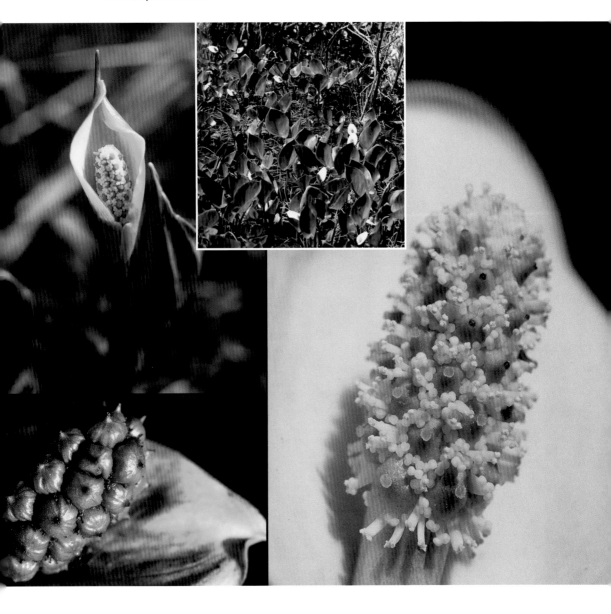

MANY MISTAKE the large, pure white spathe (curled leaf) of the wild calla as a single flower. But look closely: the clublike spadix (dense spike of flowers) is actually covered with many small blossoms. The bright red clusters of fruit are quite striking when you see them growing in a boggy area or along the lakeshore. It seems to be a race between the seedpods turning red and their consumption by some small critter: seldom do I find a complete cluster of red, ripe seeds. The wild calla likes to form a thick mat of flowers in undisturbed areas of standing water.

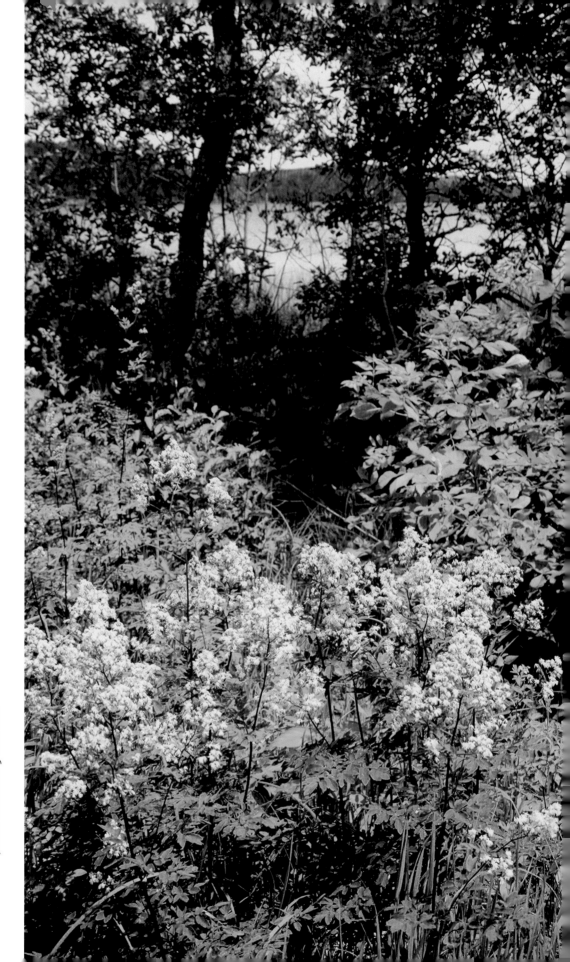

PURPLE MEADOW RUE ℬ
Thalictrum dasycarpum

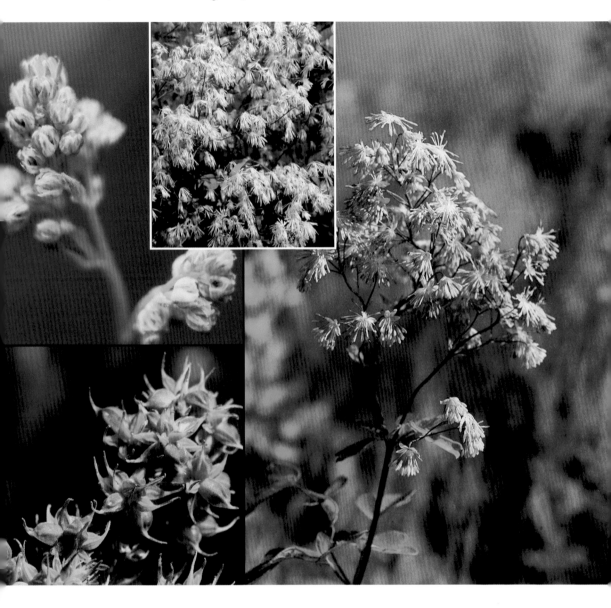

PURPLE MEADOW RUE is a real joy to behold on a windy day. The male flower presents shimmering, quivering, fringelike yellow or white drooping stamens. (They are rarely purplish, as the one pictured above.) You might have guessed that this shape suggests the wind as a primary pollinator. Purple meadow rue often has distinctive purple stems. Don't miss the final season in this plant's life, when it displays magnificent, multihued seed clusters. Early American Indians believed that hiding the seeds in a quarrelling couple's food would help love overcome problems. Of course, as this book's introduction cautions, do not gather and consume the seeds.

LESSER STITCHWORT
Stellaria graminea

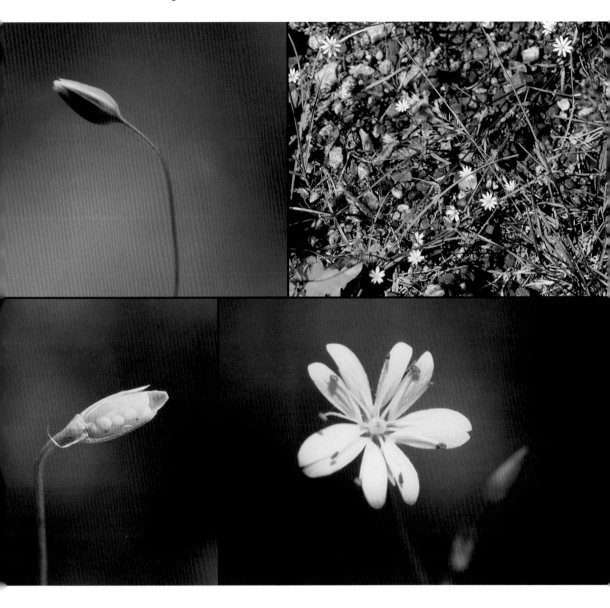

ONE OF THE DAINTIEST STARS at your feet just might be the lesser stitchwort. City dwellers who think it looks a bit familiar may have tried to eradicate its cousin, chickweed, from their beautiful green lawn, evidence that location goes a long way in determining whether a plant seems to be beautiful and charming or a nuisance requiring elimination. The red anthers on the lesser stitchwort make it easy to differentiate between the two. Everything about this plant is diminutive, even the leaves and the stems.

SPIKENARD ↗

Aralia racemosa

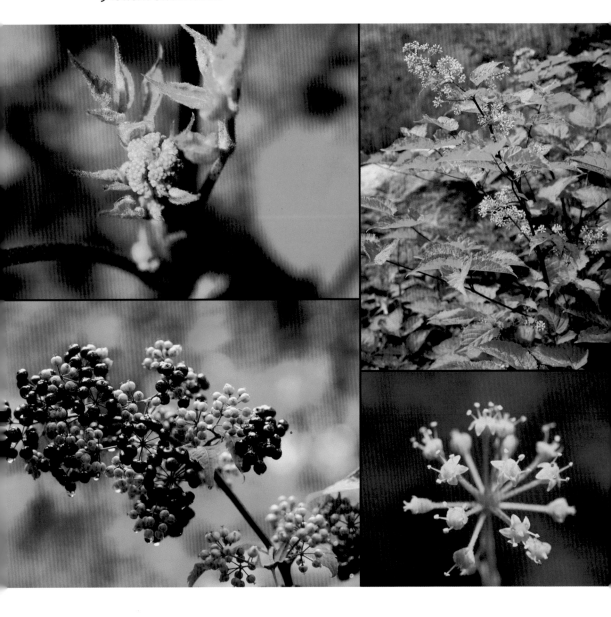

THE SPIKENARD is a member of the large ginseng family, which numbers fifty-three genera and more than 475 species worldwide. You have probably heard that another member of the ginseng family is a very popular medicinal herb in China. In Dr. James Stills's 1877 autobiography, he wrote of a remedy "for a cough of long standing" that "far excels anything that I have ever known," which included spikenard root, comfrey root, horehound tops, bloodroot, skunk-cabbage root, and other plants. I'd rather do a bit of coughing and just admire the beauty of *Aralia racemosa* and its magnificent cluster of berries. The spikenard may grow to six feet tall, with impressive spreading compound leaves.

THREE-TOOTHED CINQUEFOIL

Sibbaldiopsis tridentata

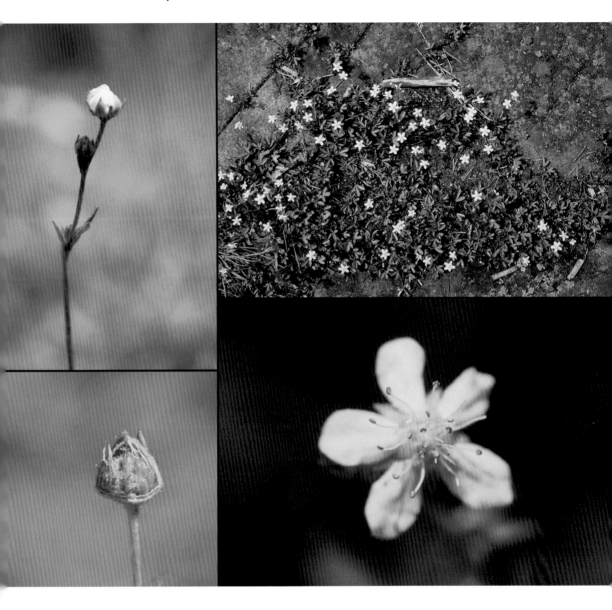

ONE OF THE SMALLER WILDFLOWERS in this collection—at just three to four inches tall—is the three-toothed cinquefoil. It seems to thrive where no other plant can live—like cracks in rocky outcroppings (see photo at left)—just like its cinquefoil cousins. The white, five-petaled flower with numerous stamens is borne at the top of upright flowering stems. Its common name refers to the three sharp teeth at the tip of each leaf. It is also called *wineleaf cinquefoil* thanks to its late-season foliage, which turns to a beautiful burgundy color.

WHITE CAMPION

Silene latifolia

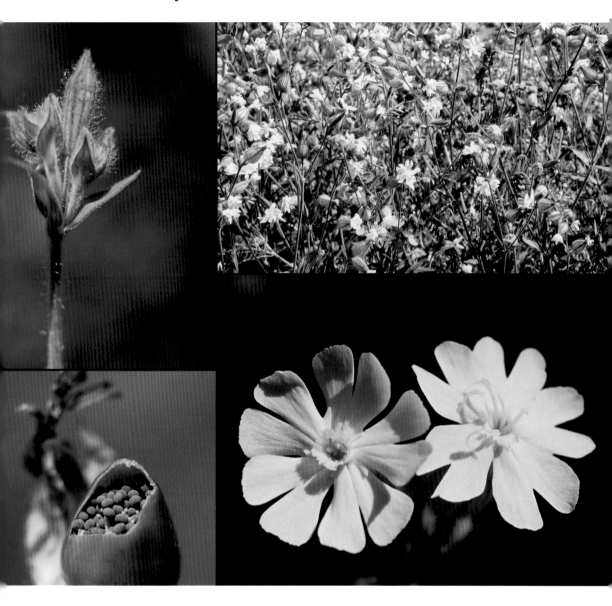

THE WHITE CAMPION puzzled me at first, until I learned that male and female flowers are on separate plants. The above photo was taken of male and female blossoms positioned together so you can readily see the difference. The female flower has five pistils extending from its center and produces a large, bladder-like calyx (cIrcle of sepals). Male flowers have a more tubular calyx. You have to get up early or stay up late to see this nighttime flower in full bloom. Look closely at the pattern on the seeds nestled safely in their own hard-shelled, highly polished capsule. A curious superstition associated with this plant is that if you pick this flower, you will be struck by lightning. Perhaps I should seek shelter during the next thunderstorm.

Mid-season Flowers

THIMBLEBERRY ℬ

Rubus parviflorus

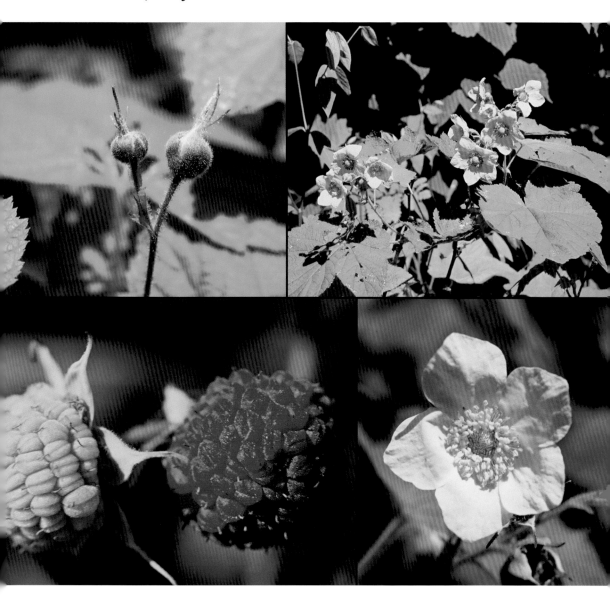

SOME OF THE THIMBLEBERRY'S characteristics will remind you of other, more familiar plants. In the flowering stage, with five petals and many stamens, the blossom hints at being a member of the rose family. In its fruiting season, it might be mistaken for a raspberry. Its leaves are similar to those of the maple tree. But this plant really needs no comparisons. The large (one-and-one-half-inch), showy white flowers, the extra-large (up to eight-inch) "maple leaves," and the delicious tangy flavor are reasons enough for me to salute the thimbleberry. And, of course, the berry slips on the tip of your finger, just like its namesake.

Mid-season Flowers

WATER PARSNIP ♋

Sium suave

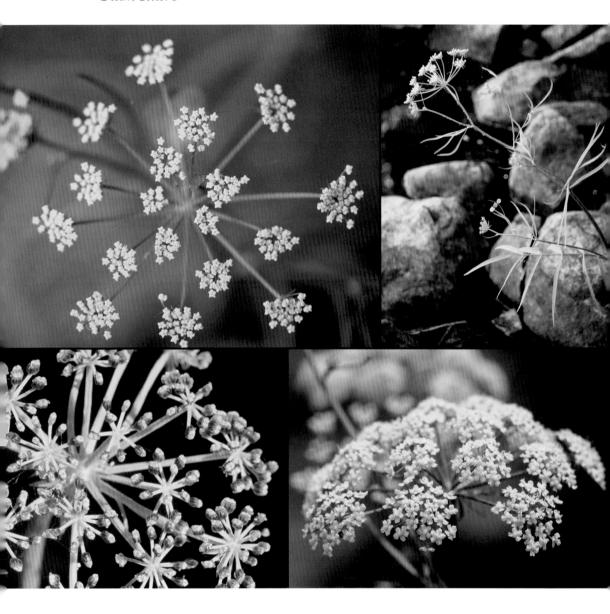

THE WATER PARSNIP is often confused with the extremely poisonous water hemlock, *Cicuta maculate,* and poison hemlock, *Conium maculatum.* All three present small white flowers in an umbrel (umbrella shape) at the top of their stalk. Although differences among their leaf structures exist, it seems wise not to attempt an explanation for fear of being misunderstood. The best advice: if you see a plant that resembles the water parsnip, admire it, photograph it, and respect its uniqueness but don't pick it. Buy your parsnips at the grocery store instead.

WHITE CLOVER
Trifolium repens

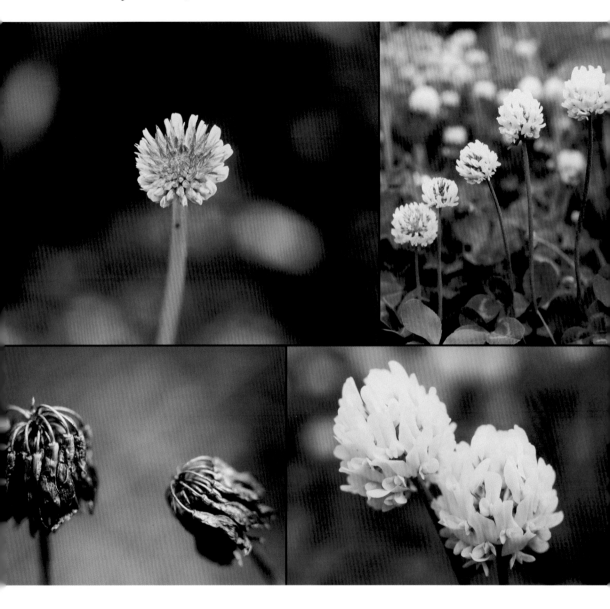

WHOEVER WROTE THE LYRICS to the popular 1950s song "I'm Looking Over a Four-Leaf Clover" must have had a patch of white clover in mind: this species offers a better chance of finding the lucky configuration than any other. The fascination with four-leaf clovers goes back to the time when anything with the shape of Christ's cross inspired much interest, when even the common three-leaf clovers carried religious significance, reminding people of the Trinity. The white clover, a native of northwestern Europe, claims the common name *Dutch clover* and also a spot in my heart: could it be because all my ancestors emigrated from the Netherlands?

WILD RASPBERRY ❦

Rubus idaeus

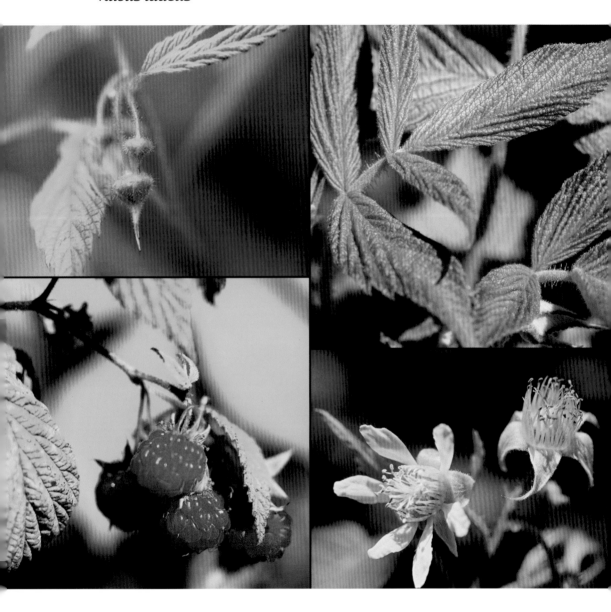

THE WILD RASPBERRY is a reward to those who live near an area that has been logged or has suffered a catastrophe like a blowdown or forest fire. I believe raspberry seeds are just lying in the ground waiting for a bit of warm sunshine so they can spring forth and produce. If raspberries grow around your cabin and you wish to be rid of them, good luck. One year I declare war on these potent plants, and the next it seems that every one is back, with a few siblings, to greet me in the early spring. The new growth's multicolored foliage deserves a second look; these bright colors return in full force late in the season. Only the most determined berry pickers can penetrate wild raspberry patches, but the yield is certainly worth the effort.

UPRIGHT BINDWEED ℬ

Convolvulus spithamaeus

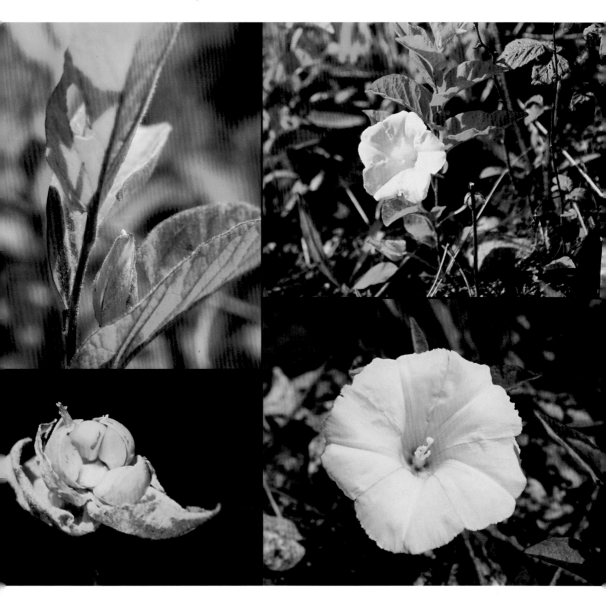

THE UPRIGHT BINDWEED BLOSSOM resembles the familiar cultivated morning glory. Two of its name-cousins, the fringed bindweed and the hedge bindweed, are vining plants like the morning glory, but the upright bindweed is not a vine. The leaf shapes for these plants differ as well: the upright (above, top left) has elliptical leaves, and the hedge and fringed bindweed have arrowhead-shaped leaves. If you see an upright bindweed in full bloom and want to photograph it, do not delay: its blossom will probably be closing soon, never to open again.

SWEET CLOVER

Melilotus alba

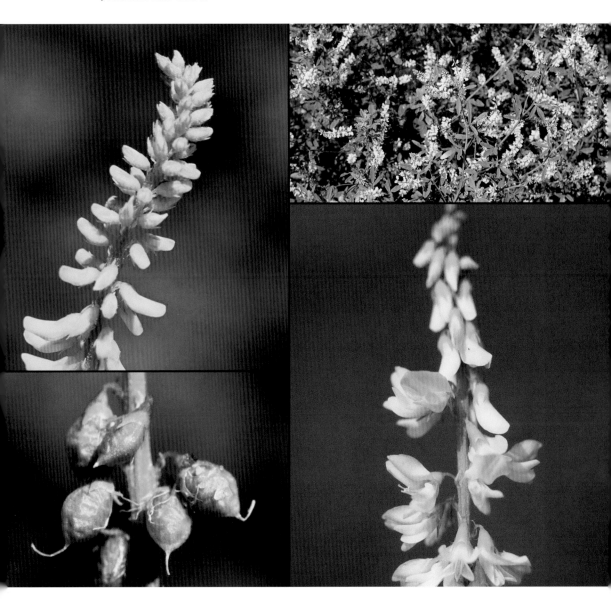

SOME WILDFLOWERS ANNOUNCE their presence before you have even seen them. Sweet clover releases a perfume distinctly its own, though some say it is much like vanilla. The fragrance seems to saturate the air, alerting your senses to wonder, "what's blooming?" Clovers are another favorite flower of honeybees; in fact, the genus name, *Melilotus,* is Greek for "honey." Unlike the familiar red clover, the white sweet clover is tall, reaching a height of four feet or more. Sweet clover found along the roadside probably was originally planted by a highway crew to prevent erosion. This invasive species is not appreciated by most visitors to natural areas.

FRINGED BINDWEED ℬ
Fallopia cilinode

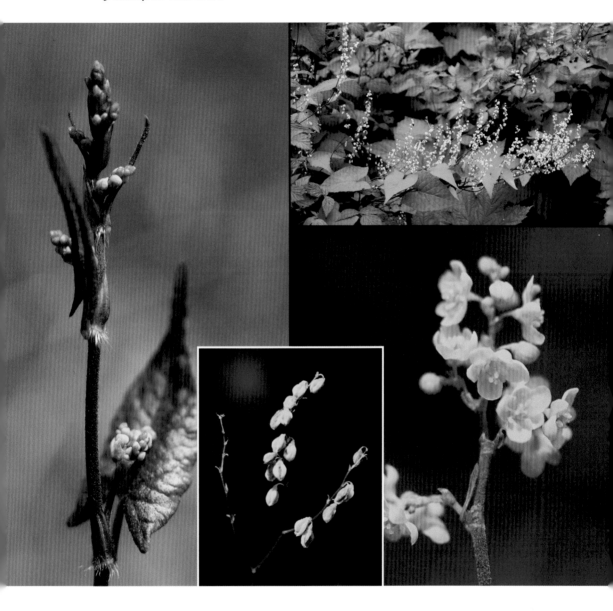

THE FRINGED BINDWEED'S BLOSSOMS are small, but hundreds usually bloom at once, putting on an impressive show. My favorite season of the bindweed is not in the summer, with its profusion of creamy white blossoms, however, but in the fall, when the heart-shaped leaves turn a brilliant red. Because this wildflower is a vine, it scatters red hearts in, under, around, and through early fall foliage or over rocky areas. And, believe me, nothing binds more than the bindweed. It is quite difficult to walk through a patch of bindweed: let's hope you are not in a hurry. Once the fringed bindweed has invaded your garden, it is extremely difficult to remove because its taproot can reach a depth of ten feet.

MEADOWSWEET

Spiraea alba

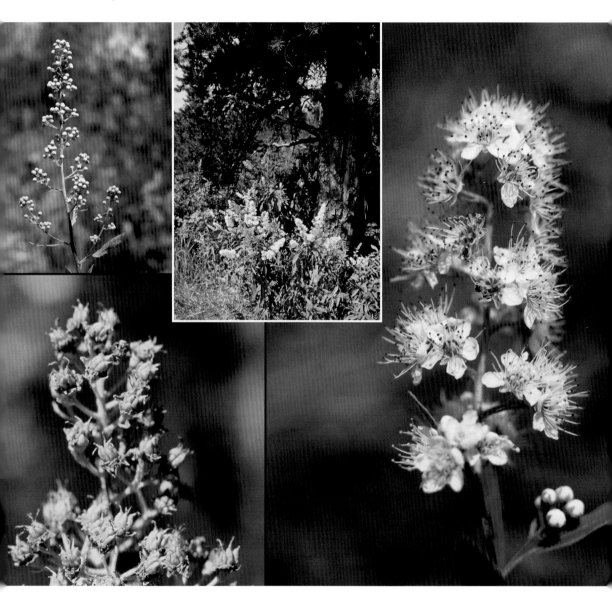

THE MEADOWSWEET, with its dense, white to pinkish terminal clusters of flowers presented in a pyramidal shape on sturdy, upright stems, would make a lovely addition to a city garden. Sometimes on a wildflower hike, the greatest pleasure teasing your senses is the total picture. On the occasion captured here, my imagination ran wild: the clouds suggested a snow-capped mountain (although I knew I was a thousand miles from one), the lake offered a deep blue stillness (though a gust of wind could change it to a rippling blue gray), and the meadowsweet's perfume was overwhelming (though a change of wind direction could carry away the sweetness forever). Faced with such a magical moment, I could only grab my camera and preserve the memory.

COW PARSNIP

Heracleum lanatum

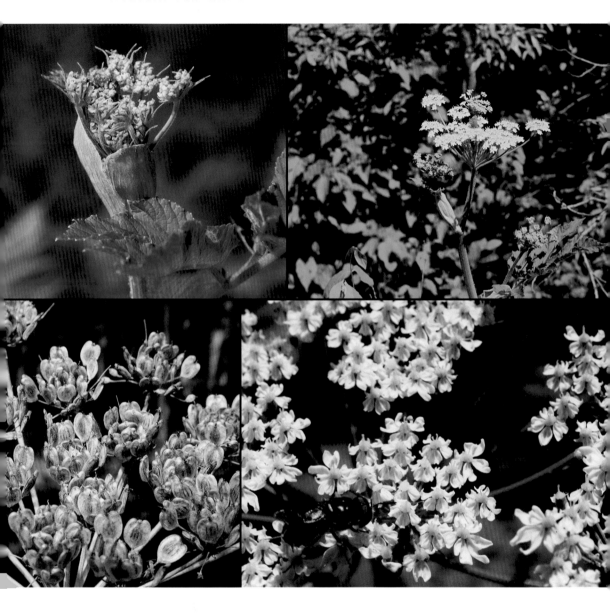

THE COW PARSNIP stands out from other wildflowers because of its size. There is nothing wimpy about this tall (four- to eight-foot) plant: heavy leaf stalks (one to one and one-half inches), gigantic leaves (eight to twelve inches), and a huge flower head (four to eight inches). American Indians have employed the cow parsnip in various ways: eating it, treating rheumatism and arthritis with its roots, and burning it to ward off evil spirits that tried to steal a hunter's luck. My favorite spot for viewing the cow parsnip is an area that suffered the ravages of a wildfire. The very next year, all the surrounding trees were gone, but the cow parsnips had multiplied and were taller and more beautiful than before.

FRAGRANT WATER LILY ❧

Nymphaea odorata

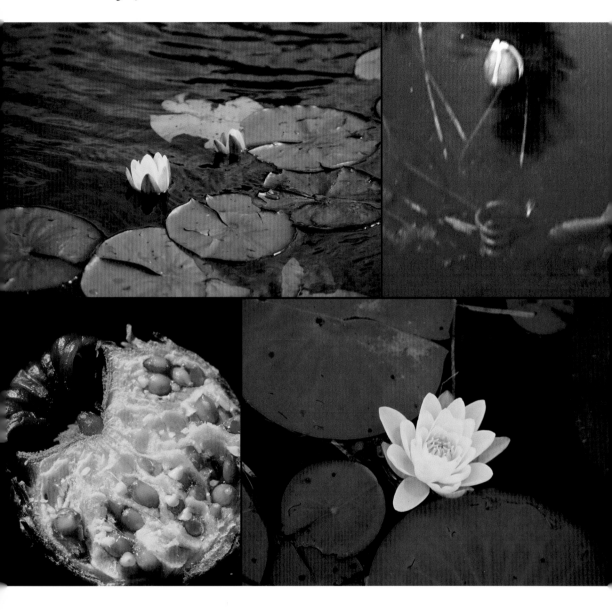

EVERYONE IS FAMILIAR with the fragrant water lily's floating white flowers and large, round, shiny green leaves. Most people probably also know that these plants grow in shallow, still water, often in bays or at lakeshore's edge. However, one characteristic that is likely not common knowledge happens after the bloom, when the seedpods are forming.

The stem of the fragrant water lily actually contracts and coils like a spring, pulling the maturing seedpod deep into the water, as pictured above. After the seeds mature, the pod splits, sending them to the surface. After they become waterlogged, the seeds sink to the bottom, and the life cycle begins again.

SLENDER LADIES' TRESSES ꙮ

Spiranthes lacera

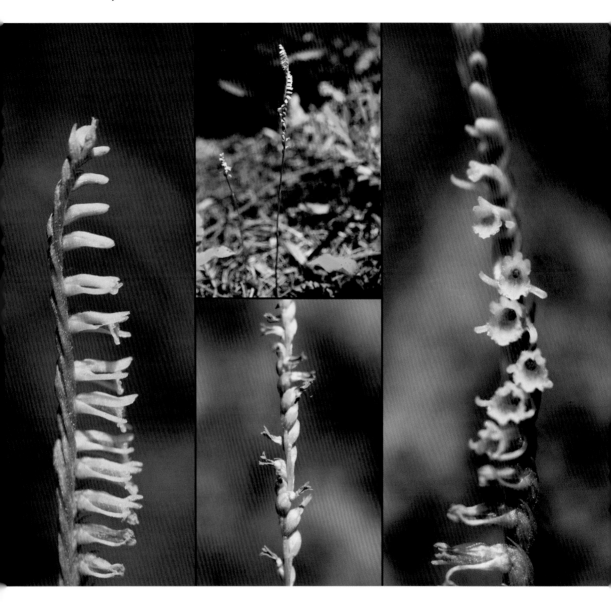

THE SLENDER LADIES' TRESSES bloom later in the season than most northern orchids, and unless you are specifically looking for them, you may never see them. Their slight stalk of blossoms is approximately one-half inch wide and stands no more than about one foot tall. A unique feature of this native wildflower is that the stem twists, forming a spiral. Bees start at the bottom of the flower spikes, which are the earliest to mature, and continue up, depositing pollen on the more mature flowers and conveniently picking up pollen as they progress to the top.

Mid-season Flowers

LESSER DAISY FLEABANE

Erigeron strigosus

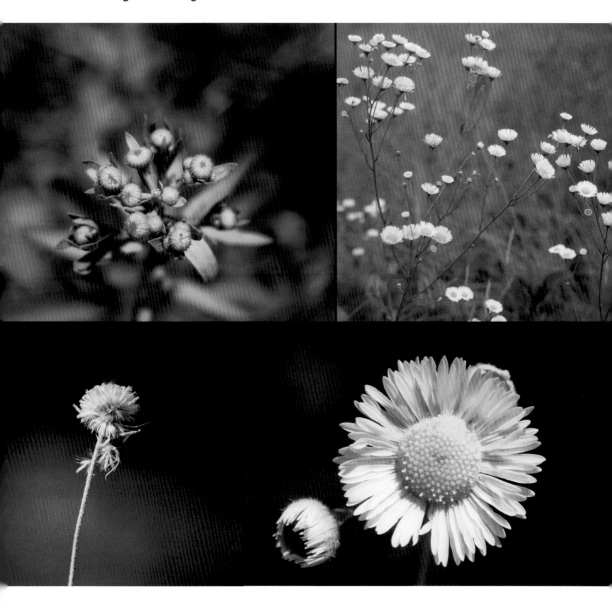

TO SOME, fleabane looks like a miniature daisy; others compare it to the asters. It might bear some resemblance to both, but once you focus on the fleabane's ray flowers—numbering fifty or more—you will not confuse one for the other. An old tale states that if a woman wanted to know the sex of her unborn child, she should plant some fleabane seeds: flowers with a pinkish cast meant she was having a girl, while a bluish cast predicted a boy. Another theory—that fleabane repels insects—is probably more believable.

ROUND-LEAVED ORCHID ℘

Platanthera orbiculata

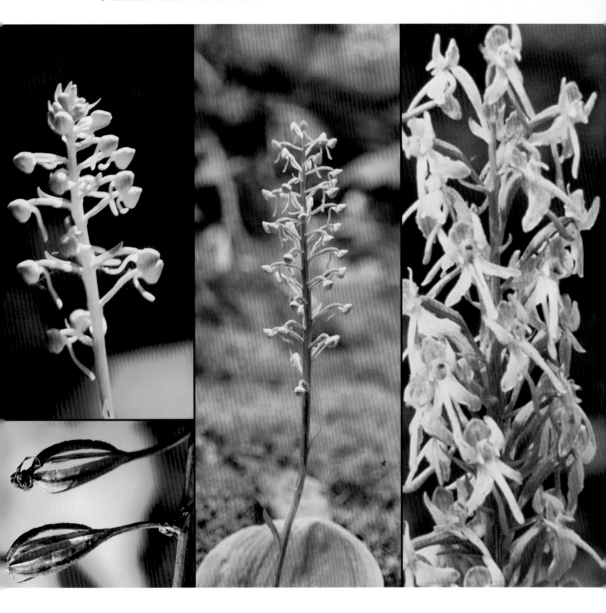

IN 1994, while hiking on the Kekekabic Trail (a forty-five-mile, low-maintenance path mostly in the Boundary Waters Canoe Area Wilderness), I saw a round-leaved orchid that earned an eleven on a scale of one to ten. As its name implies, it has two rounded basal leaves. Its greenish white flowers have a long tapering lip and an even longer spur (hollow appendage) projecting downward. During the rest of the season, I visited this plant and looked for others in the immediate area but didn't find any. For the next decade, I went back every year, and it never reappeared— not even a leaf. What a gift that orchid was. Sometimes I wonder how many human eyes looked at it before it faded and returned to its long slumber. The round-leaved orchid is not unique in its absence: other plants take many years to store up enough energy to produce a single flower.

PURPLE PEA ❀

Lathyrus venosus

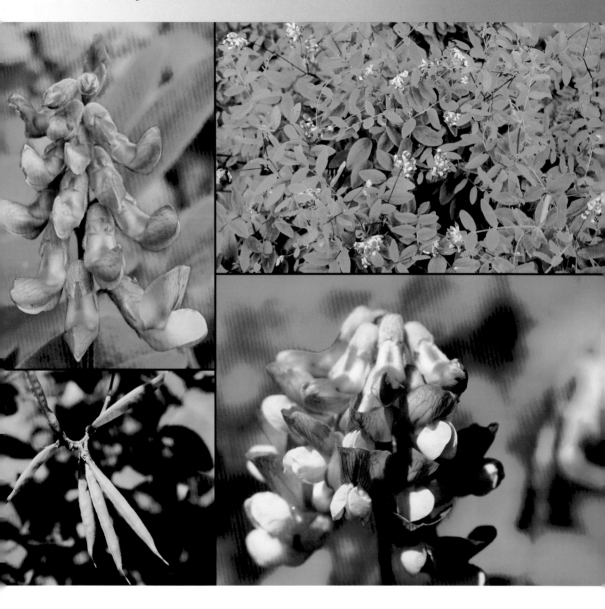

CALL THIS WILDFLOWER "purple pea," "wild peavine," or "veiny pea"—all common names for *Lathyrus venosus,* one of the most attractive members of the legume family. You will know it's not an escaped garden sweet pea when you notice it has as many as twenty blossoms on its flower stem. Tendrils at the stem's terminal wrap around nearby plants, helping keep the purple pea in an upright position. As you might expect, its seedpod resembles the pea pods you've picked from your garden or purchased in the grocery store, but in miniature.

SPREADING DOGBANE ❦

Apocynum androsaemifolium

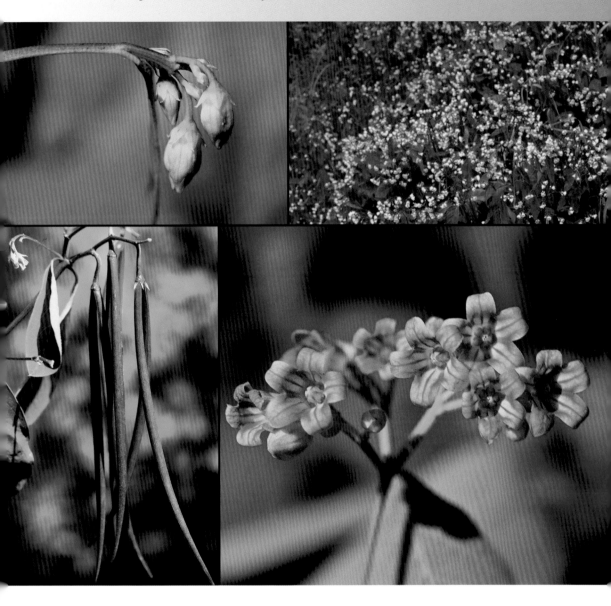

WHEN CONSIDERING THE SEASONS of the dogbane, perhaps the first thing that comes to mind is that its foliage, changing from blue green to a mellow yellow, is one of the earliest signs of autumn. Once you have focused on its seedpod, you will probably agree that its warm, deep red, gracefully tapered pods are the dogbane's most outstanding characteristic. The blossoms come in quite a variety of pink tints, sometimes with only a hint of color. Wildflowers are our friends in ways seldom recognized, and dogbane is no exception. A powerful drug for slowing the pulse, apocynum—one of the digitalis group of medicines—was once extracted from this plant.

PINK PYROLA

Pyrola asarifolia

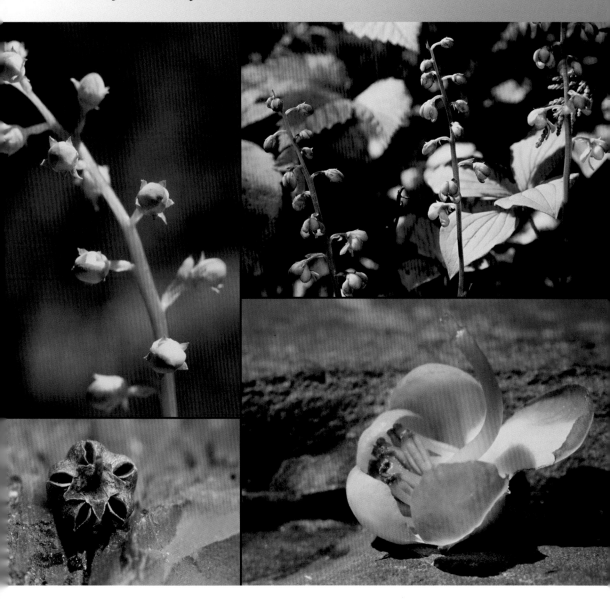

WHEN HIKING IN THE MOIST WOODS, you might encounter members of the wintergreen family, notably the pink pyrola, whose flower stem rises about six to eight inches above its dark green, shiny, basal (ground-hugging) leaves. Perhaps nearby you will see a white pyrola, also known as shinleaf—appearing like a twin to the first, simply wearing different-colored blossoms. One common name is rheumatism weed because the American Indians have used pyrola to relieve aching joints. Notice the flower's unusual shape, with an elongated, arching style rising out of its bed of pink petals. I wonder if Georgia O'Keefe ever painted the pink pyrola.

BLADDER CAMPION

Silene vulgaris, Silene csereii

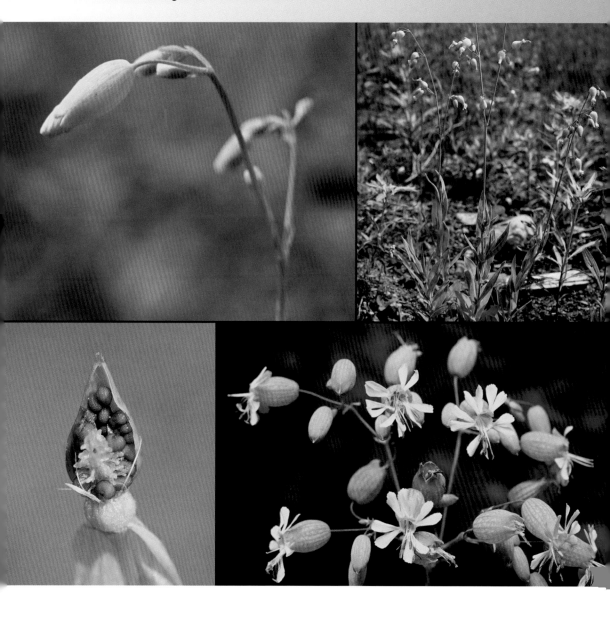

THE FLOWER OF THE BLADDER CAMPION offers beauty in many forms, as its soft mauve color, sculptural shape, lacey petals, feathery stamens, smooth texture, and delicate veining all add up to a rather pretty package. The bud and plant pictured above is a cousin, the smooth catchfly, *Silene csereii*. In 1657, a Swiss physician developed the doctrine of signatures theory, which held that if part of a plant resembled a part of the human body, the plant would heal it. Following this theory, the bladder campion would be used to treat diseases of the bladder. I wonder how many of today's urologists have even heard of the bladder campion.

PITCHER PLANT ℬ
Sarracenia purpurea

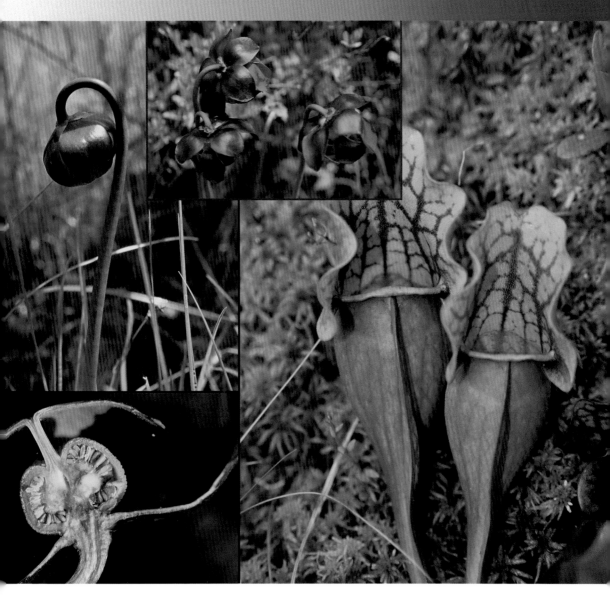

GRAB YOUR BOOTS for a hike to the bog that the carnivorous pitcher plant calls home. This wildflower relies on protein from insects to sustain itself. The leaves are pitcher shaped and slippery, with downward-pointing hairs. Once the insect is in, it slides into enzyme-rich liquid out of which it cannot crawl—and then it's absorbed for dinner. Sometimes a spider will make a web over the pitcher's mouth, catching insects and robbing the plant of its tasty treat. Magnificent, deep red flowers with drooping petals rise above the bog and announce the position of its pitchers. As the seasons progress, it continues to delight with a most unusual seed package (cross section, above).

ALSIKE CLOVER
Trifolium hybridum

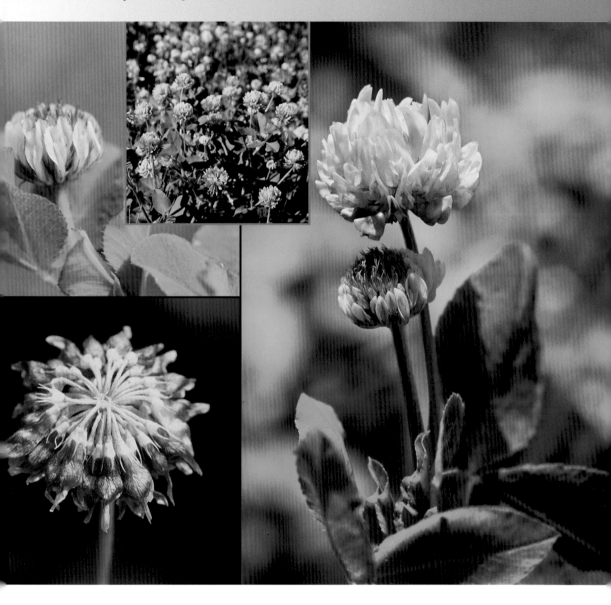

THIS PLANT, native to Alsike, Sweden, carries a geographical common name. Beyond the unique moniker, it is just another sweet-scented, round-headed clover like many others. Three clovers with similar flower heads in this volume show quite different fruiting stages. The red clover's seed season looks similar to its blooming season, except that it takes on a crisp, dry, brown appearance. A stage in the white clover's seed head almost looks like a brown water fountain. And the pink (alsike) clover flattens out into another attractive floral shape, its pale green center edged with tinges of russet brown.

RED CLOVER

Trifolium pratense

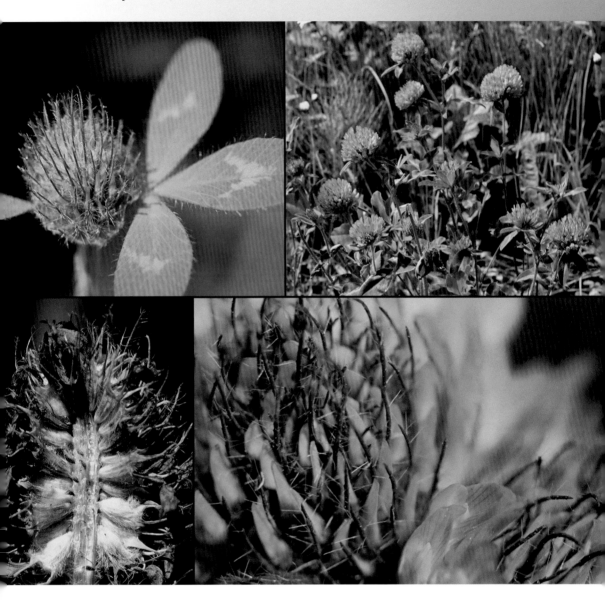

CHILDREN WHO LIVE near a country road could tell you something the butterflies and bees also know: the individual florets from the clover flower head offer a drop of very sweet nectar. I speak from experience: walking home from a rural, one-room school (eight grades, forty children, one teacher), I would search for the red clover and enjoy its tasty treat. If you see bees frequenting the clover at a certain time of day, you can predict that they will return at the same time the next day. Bees remember the prime time for nectar harvest in different species of wildflowers and never seem to be late for dinner. The leaves of the red or white clover are easy to identify because of their distinct lighter green chevron—a pattern also adopted by logo designers at a major oil company.

MUSK MALLOW
Malva moschata

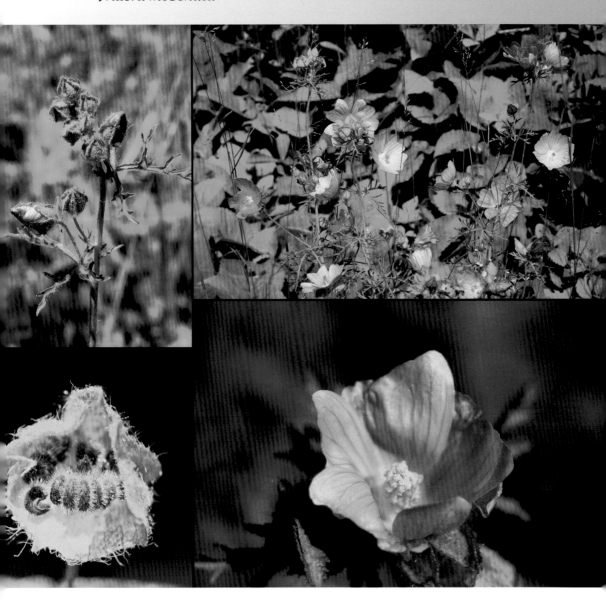

THE FAMILIAR TALL HOLLYHOCK, an old favorite of the mallow family, used to be a popular resident in grandmothers' flower gardens. The musk mallow's flower, with its prominent center column (female style) surrounded by male stamens, resembles the hollyhock. The large pink (sometimes white) petals with their intricate veining are quite beautiful. If you find a plant one to two feet tall with intricately cut leaves and five pink, wedge-shaped petals, it probably is the musk mallow. I appreciate the large, pink flowers, but most intriguing is the plant's final season, when its fruit is tucked in a spherical, papery package that, upon opening, displays black hairy seeds nestled in a neat circle.

RABBIT'S FOOT CLOVER
Trifolium arvense

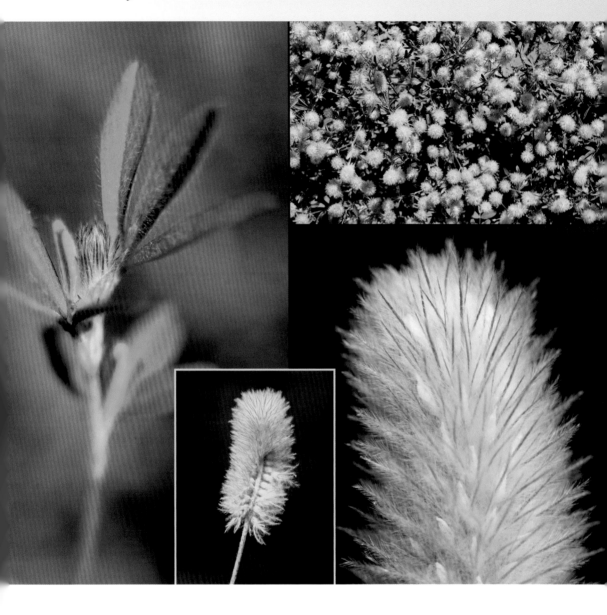

NO ONE HAS SUGGESTED that this clover brings good luck, but with a name like *rabbit's foot*, it wouldn't hurt to put one in your pocket and see what happens. This plant likes to grow along the edge of the road, forming a wide ribbon of pink puffs. The rabbit's foot clover is an everlasting plant: cultivate some in your wildflower garden, pick it in its prime (when its hue is most intense), hang it upside down in a dark, dry place, and enjoy it all winter long. Arrange it with some dried pearly everlasting for an interesting color and texture combination.

CROWN VETCH

Coronilla varia

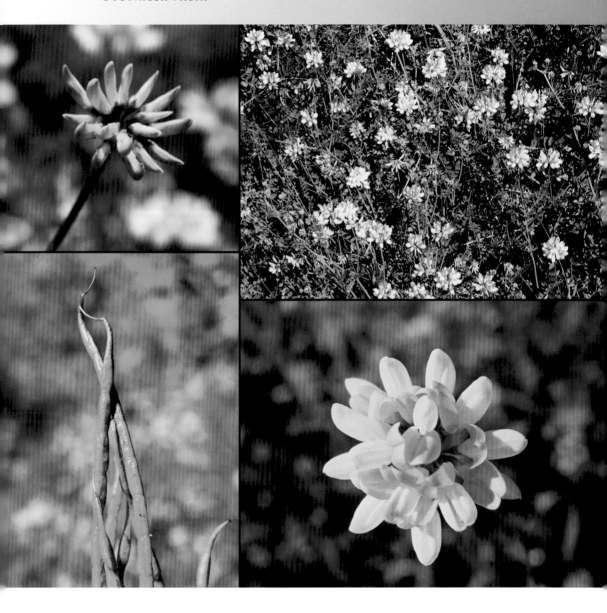

MOST OF THE TIME when you see crown vetch blooming along the roadside, it has been planted to control erosion, a history it shares with a few other wildflowers in this collection. After small animals and birds enjoy the fruit, they travel a distance before expelling the seeds, and the life cycle begins in a new place. In this way, wildflowers concentrated in one geographical area expand their boundaries. The crown vetch resembles—what else?—a crown of pink and white, pealike blossoms. Once established, crown vetch appears to be just waiting for a coronation.

WOOD LILY ☙

Lilium philadelphicum

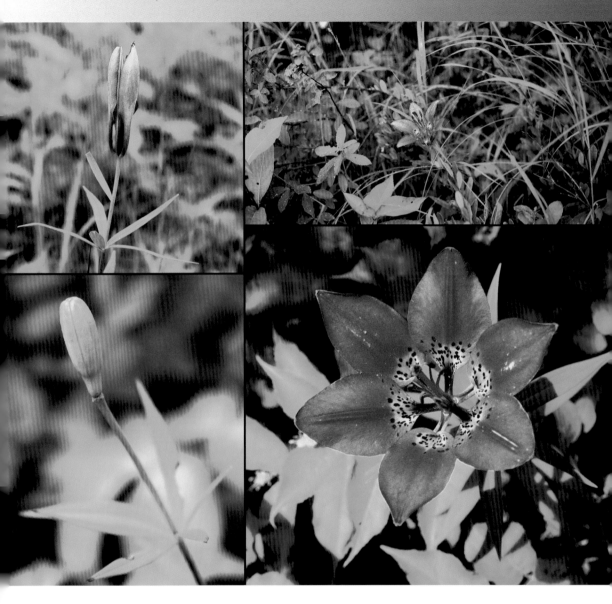

THE CHANCE OF FINDING two or three wood lilies on your hike is somewhat slim unless you remember where they were blooming the previous season. Thankfully, if one is within your line of vision, you probably won't miss it because of its large, showy blossom and intense orange color. Mother Nature is rather stingy with her orange palette, saving it for only a few wildflowers. The seedpod carries many hard-cased seeds that don't seem to have a very successful germination rate. Perhaps this seed would welcome a little human help to tuck it into the topsoil—though this assistance, technically speaking, would cost it its status as a true wildflower. A familiar legend tells that all lilies were white until Christ, in the garden of Gethsemane, looked upon one, which was so overcome with shame at its unworthiness that it blushed and bowed its head. Red lilies appeared after that encounter, and only a few hold their heads upright, the wood lily being one of them.

KING DEVIL HAWKWEED 🌿
Hieracium piloselloides

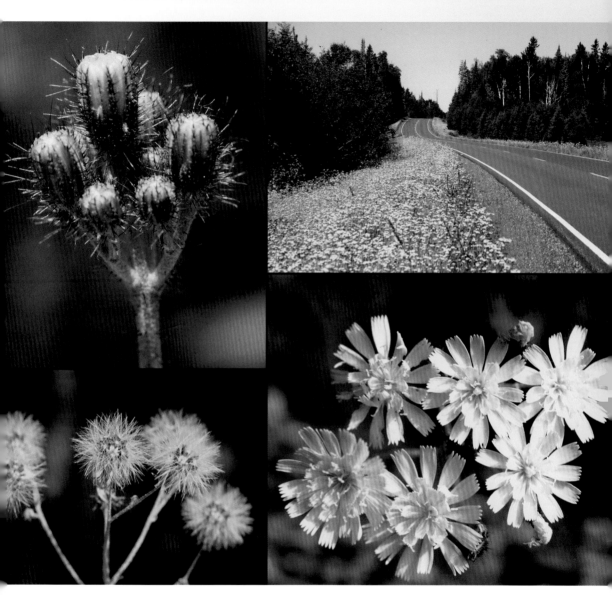

THE YELLOW HAWKWEED, also known as king devil, that thrives in my wild neighborhood is probably our most prolific and invasive wildflower. In full bloom around the Fourth of July, its flowers form yellow rivers gracing roadside ditches for miles and miles. To see yellow hawkweeds at their best, choose a bright, sunny day. Just like their orange hawkweed cousins, they close their blossoms on dark, cloudy, or rainy days and in the late afternoon. In other words, don't pick king devils to grace your dinner-party table: they will be sound asleep by the time the guests arrive.

YELLOW GOATSBEARD
Tragopogon dubius

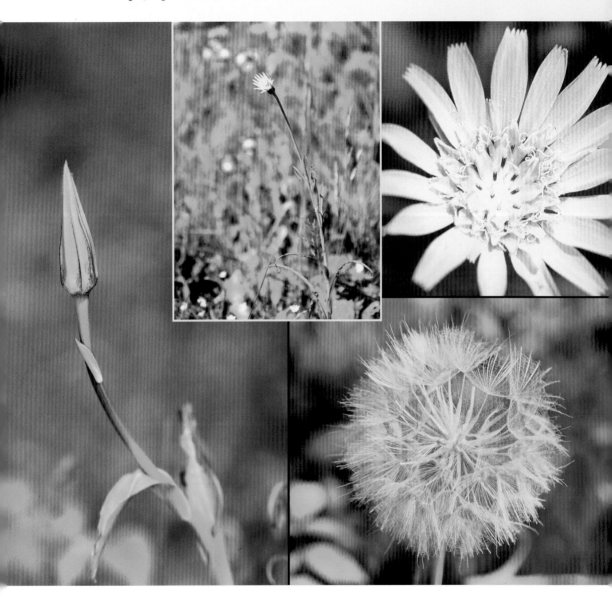

YELLOW GOATSBEARD is one of many wild-flowers—like cow parsnip, sow thistle, dog-bane, and horseweed—that carry an animal name. A close encounter with a *real* goat's beard would make clear the connection to this flower's stiff and hairy seed head. Goats-beard faces the sun, making it a photographer's friend by casting its shadow behind.

But you must be an early riser to look into the face of this plant: it closes its blossom by noon. The seed head will remind you of the common dandelion, only the goatsbeard is much larger and stiffer. It finds its way into dried floral arrangements, adding an interesting shape and texture to the bouquet.

BLACK MEDICK

Medicago lupulina

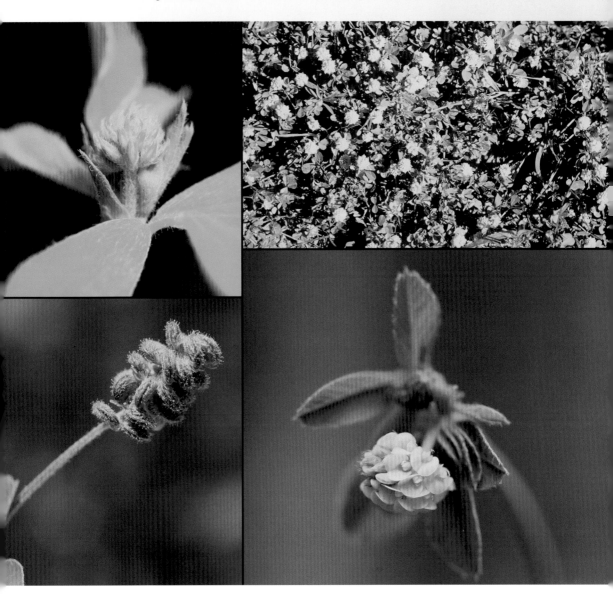

THE BLACK MEDICK, a very short plant usually not more than three to five inches tall, often shares its environment with taller flowers, as seen on the left. Daisies are good neighbors, allowing plenty of sun to filter down to the medick. Sometimes it cohabits with the bird's-foot trefoil, and the two—both sunny yellow and with a similar leaf structure—blend so well that, unless you are quite observant, you might think they are one plant. The bird's-foot trefoil is taller, with a much more impressive flower head: perhaps the medick has an inferiority complex. This plant gets its name from its fruiting stage, when the tiny, twisted seeds turn black.

ORANGE HAWKWEED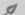

Hieracium aurantiacum

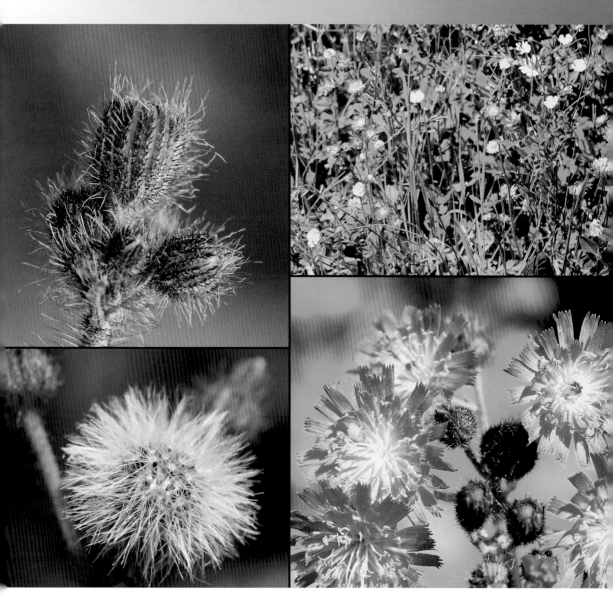

THIS PLANT, thought to improve eyesight, earned its scientific name from the Greek word *hierex*, meaning hawk, a raptor known for its keen vision. Immigrant herb doctors brought the hawkweed to America to treat eye diseases. Its common name *devil's paintbrush* reflects the blossom's shape and the plant's ability to spread quickly, taking over good pastureland. On dark, rainy days, hawkweeds sleep, never opening their blossoms. If the sun is shining the next morning, they awake refreshed and open their petals to present a shocking, bright orange flower.

BIRD'S-FOOT TREFOIL 🌿

Lotus corniculatus

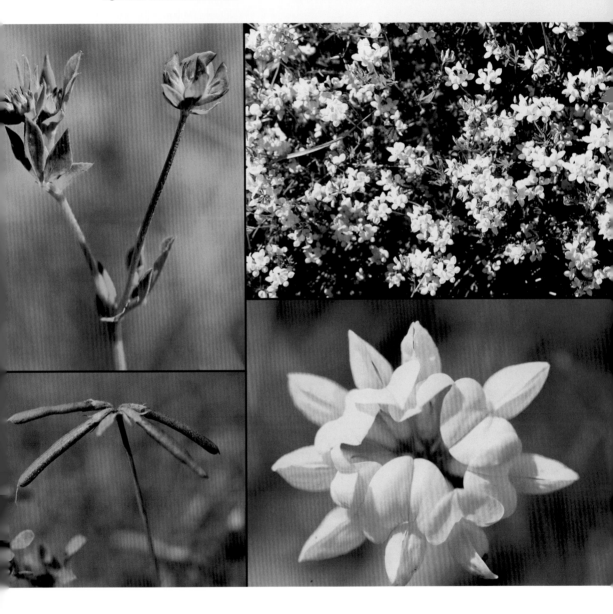

ONCE YOU'VE FOCUSED on the bird's-foot trefoil, you will not mistake it for any other wildflower. Five to six individual, bonnet-shaped blossoms form a most attractive bright yellow rosette. And with perhaps thirty rosettes on each plant—and hundreds of plants growing together in some areas—the effect is acres of yellow. Attractive though it may be, this introduced species is crowding out some of our native plants. I live with the trefoil because when the gravel for our drive-way was delivered, it contained thousands of seeds, making my drive not the yellow brick road but the yellow bird's-foot road. This plant saves its most unusual characteristic for the end of its growing cycle, when its seedpods resemble a bird's foot. One early fall day, I saw a yearling black bear snacking on the seed-pods, oblivious to their unusual shape—and, thankfully, to me.

BULLHEAD LILY 🕉

Nuphar variegata

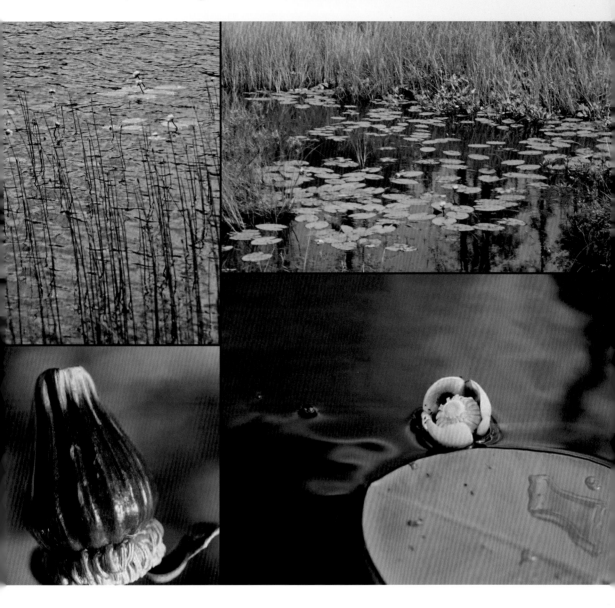

THE BOREAL FOREST'S LARGEST ANIMAL, the *Alces alces*—commonly known as the moose—can often be found munching on the bullhead lily. Muskrats and beavers add the leaves and rootstalks to their menus as well, and ducks eat the seeds. The two-inch, cup-shaped flower is visible from quite a distance, rising above slow-moving streams, on ponds, on bays, or along lakeshores. The seed-pod of the pond lily (another common name) matures beneath the water's surface and is seen by only the most inquisitive of wild-flower enthusiasts. Its deep red color and sculptural shape is certainly a reward for the extra effort. American Indians ground the dried roots into flour.

HONEYSUCKLE ॐ

Lonicera hirsuta, Lonicera dioica

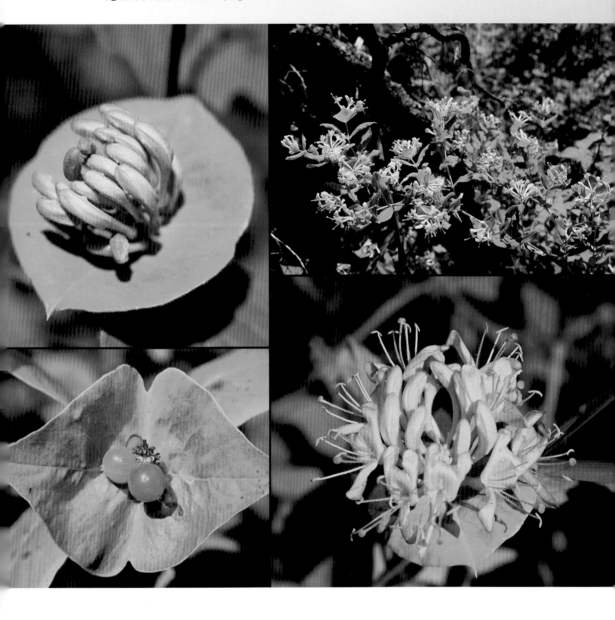

FEW WOODY VINING PLANTS frame their blossoms or seed clusters in so interesting a way as the honeysuckle. Their leaves are egg-shaped and opposite (on *L. hirsuta,* hairy; on *L. dioica,* hairless). The last pair, at the terminal of the vine, fuse together to form a saucer around the flower or fruit clusters. Pictured here, the bud is the hairy honeysuckle *(L. hirsuta),* and the seed is the wild honeysuckle *(L. dioica):* notice the difference in the shape of their terminal leaves. The tubular yellow flowers turn red as they age. Honeysuckle is a great climber, twisting its tendrils around tree trunks. Shakespeare referred to the plant in *A Midsummer Night's Dream:*

> *Sleep thou, and I will wind thee in my arms.*
> *So doth the woodbine the sweet honey-*
> *suckle gently entwist.*

EVENING PRIMROSE 🎕
Oenothera biennis

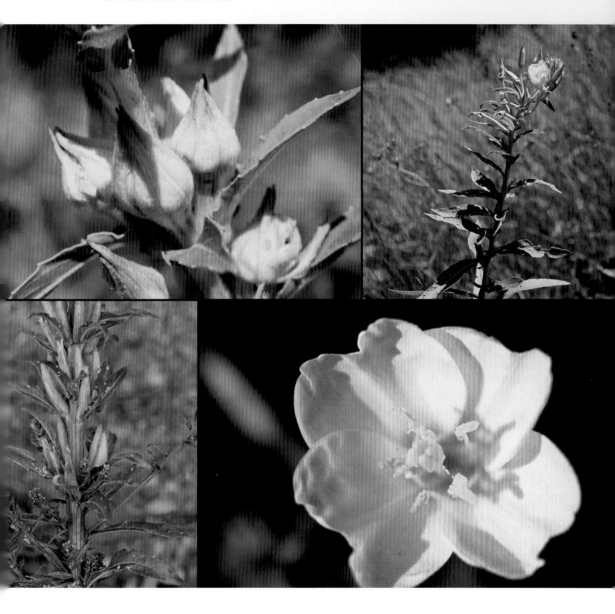

AS ITS NAME SUGGESTS, this flower is in full glory in the evening, inviting nocturnal moths to come pollinate. At season's end, you'll find a bright red–foliaged plant, its seedpods resembling a bunch of bananas. Its genus name reflects the Greek *oinos,* "wine," and *thera,* "to hunt." Perhaps some folks were hunting for a good wine to celebrate the beauty of wildflowers when they named the evening primrose. Its oil has proved promising in the treatment of asthma, migraines, arthritis, acne, weight loss, and other maladies. It reminds us to respect and protect all wildflowers: so many of their secrets are yet unknown. Ralph Waldo Emerson alluded to this sentiment when he said, "A weed is a plant whose virtues have not yet been discovered."

COMMON ST. JOHNSWORT 🌿

Hypericum peforatum

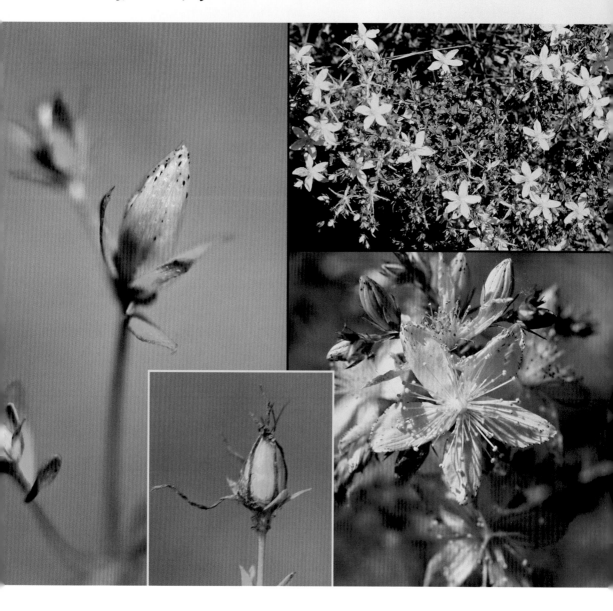

NOT TOO MANY YEARS AGO, this wildflower seemed to be the next antidepressant drug, for a time outselling Prozac eight to one in Germany. However, in 2002 the *Journal of the American Medical Association* reported that St. Johnswort had little value in treating depression of "moderate severity." The plant does have a few mystical-seeming physical characteristics: for example, the yellow flower petals turn reddish when crushed. Some believe St. Johnswort had a connection with the beheading of John the Baptist, for whom the plant is named. Another story recounts that the angry devil stabbed the plant with a pin, evidenced by transparent spots on the leaves. Those spots are actually oil glands.

AGRIMONY ✿

Agrimonia gryposepala

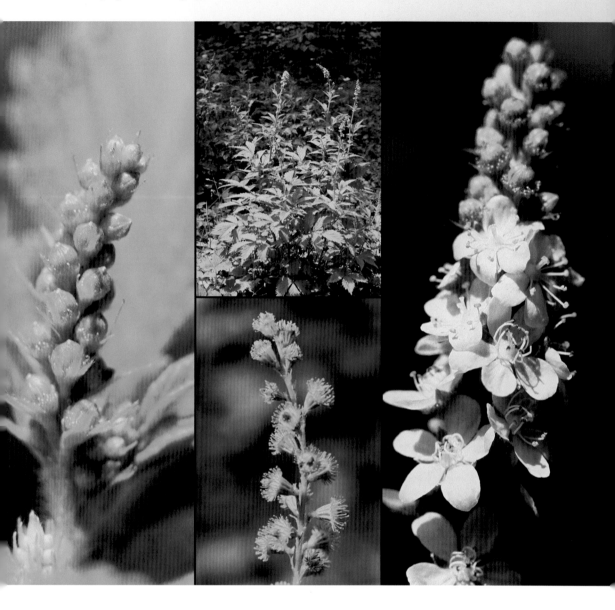

AS SOON AS THE AGRIMONY's five-petaled yellow flowers fade by my cabin door, I clip the flower heads before the seeds have a chance to become a nuisance. Of course, a few inflorescences (the flowering portion) are left so Mother Nature can scatter and plant again for next year's bloom. Your attention will be drawn first to the unusual seedpod, with its grooved, dunce-cap shape, and then, if you are not extremely careful, by the many seedpods clinging tightly to your sleeve or trousers. I like the agrimony for its coarsely toothed compound leaves, which form a dense, green plant that provides a good filler in my wildflower garden.

Mid-season Flowers

BLACK-EYED SUSAN ❧

Rudbeckia hirta

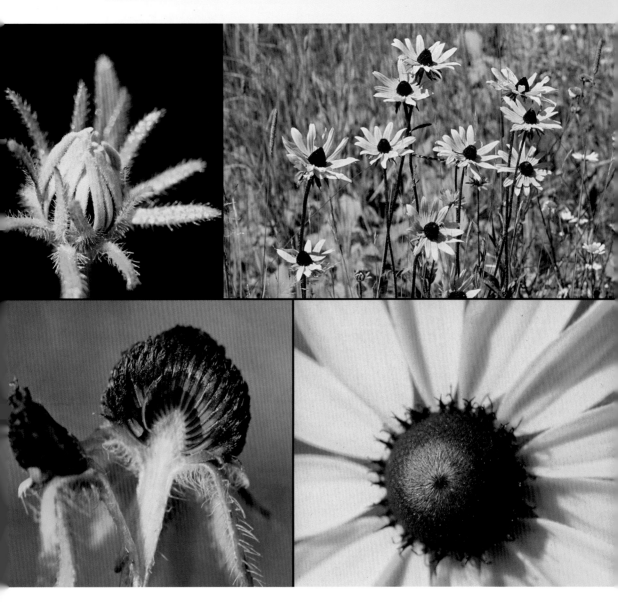

THE COMMON NAME *black-eyed Susan* is a bit misleading because the eye (disk) of the blossom is actually reddish brown. In an eastern state, it is known as brown-eyed Susan, certainly more descriptive. The scientific genus name *Rudbeckia* was given to this plant by Swedish botanist Carl Linnaeus to honor his botany teachers, Olaus Rudbeck and his son Olaus Jr. It is a bit curious that Linnaeus gave this "foreigner's name" to a native American wildflower. The colors and pattern of the seeds in the head are impressive. The yellow ray flowers have given up their reproductive function and simply serve to grab insects' attention.

Mid-season Flowers

NORTHERN BOG ORCHID ❧

Platanthera huronensis

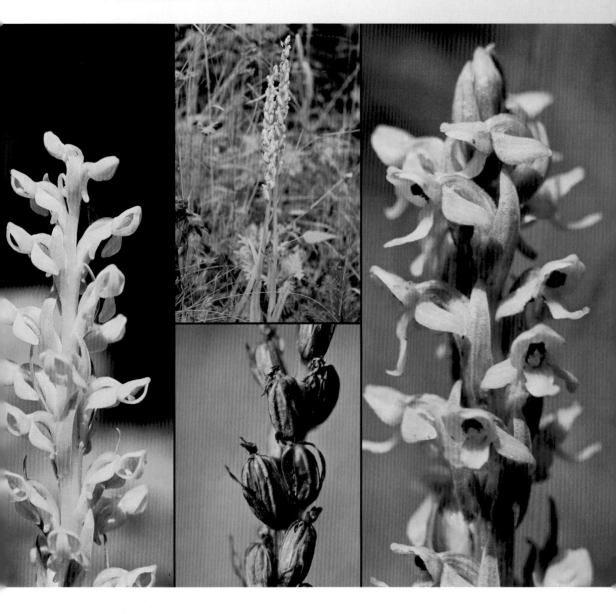

THE NORTHERN BOG ORCHID can easily be overlooked because its small greenish flowers blend in with the surrounding foliage. This wildflower seems happiest living in a damp ditch or depression at the edge of a roadway or hiking trail. While many field guides suggest this species grows to three feet tall, in all my years of visiting bog orchids, I have never seen one taller than about twenty inches. Insect pollinators consistently do a good job with this plant, helping produce a healthy, full stalk of seed capsules. If the generous number of seeds on the solitary orchid I found growing in our woods five years ago accounts for multiple plants in four separate areas this year, it certainly supports the theory of wildflowers expanding their territories.

WILD COMFREY

Cynoglossum virginianum

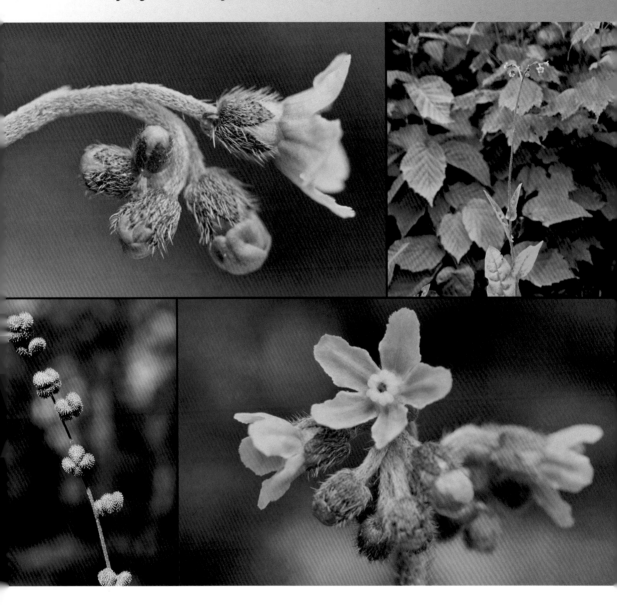

TWO YEARS AFTER a devastating blowdown, wild comfrey appeared next to one of my walking paths at our cabin. The unusual large, tongue-shaped leaves piqued my interest as I waited for the plant to bloom, but the small, blue blossoms were a bit of a disappointment. Later, the four prickly nutlets grabbed my attention, first with their beautiful sculptural shape and then when they found our friendship so satisfying they didn't want to let me go. Another common name for wild comfrey is dog burr, and you will know why if your canine companion is out on the hiking trail when the wild comfrey seeds are ripe.

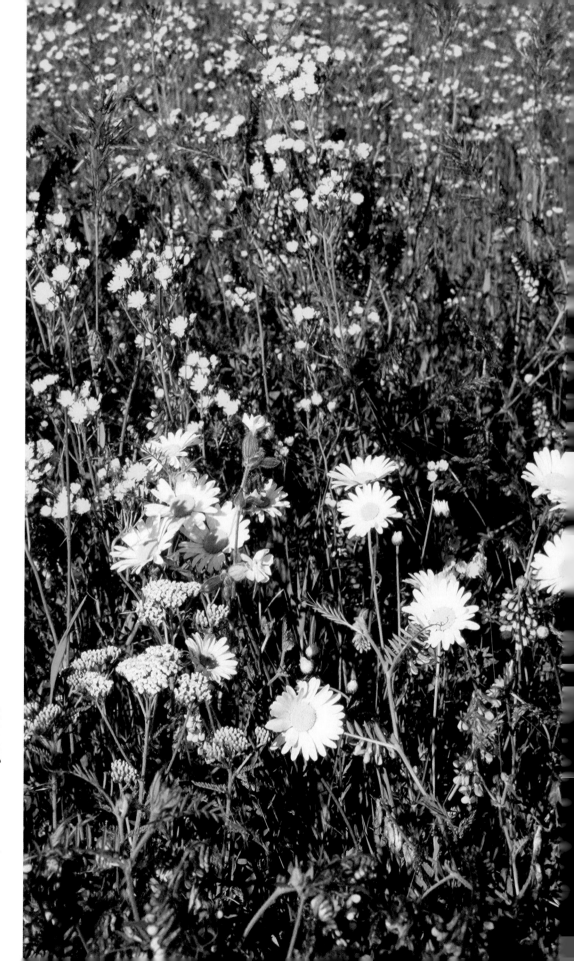

Mid-season Flowers

TUFTED VETCH

Vicia cracca, Vicia villosa

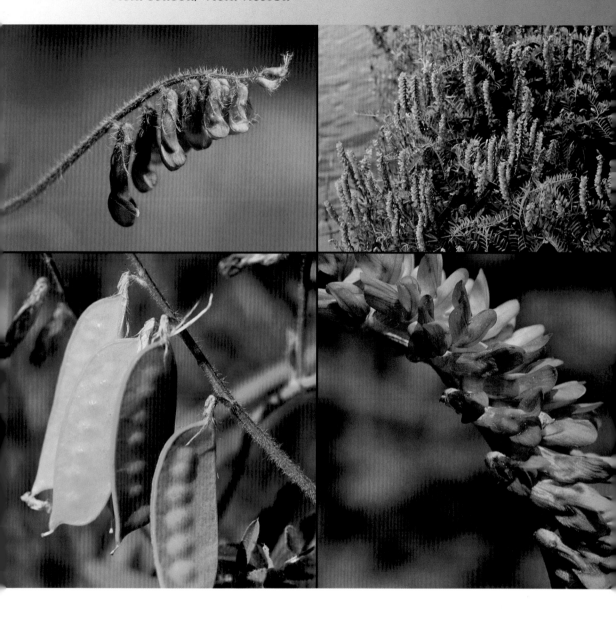

TUFTED VETCH is also known as cow vetch, probably because it was used for fodder. *Vetch* and *vicia* are derived from the Latin *vincire,* meaning to twist or bind, which is certainly descriptive of most vetches. The tufted vetch is the easiest to identify because the bright purple flowers—as many as thirty in each inflorescence—are all on one side of the stem. Rest assured: if you're out hiking any time from June to September, you should be able to find a tufted vetch either hiding in one of nature's bouquets or playing the leading role along the edge of your hiking trail. Its cousin the hairy vetch, Vicia villosa, is shown in the photo at left. Note the distinctive bi-colored flowers.

ALFALFA

Medicago sativa

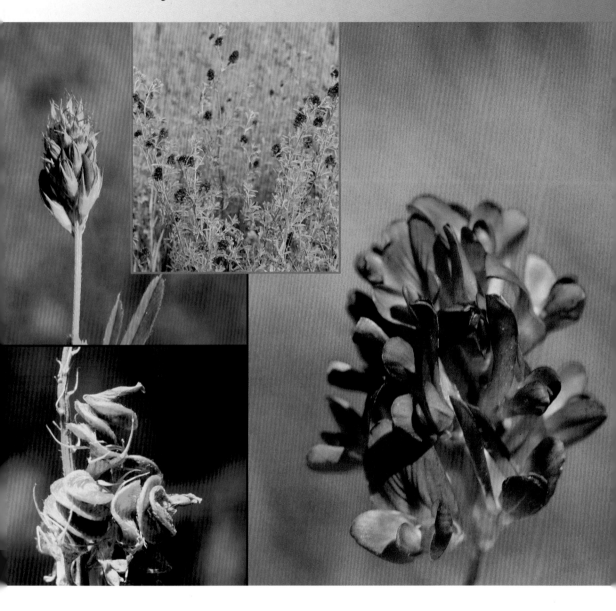

ALFALFA IS A FRIEND to farmers, offering forage and improved soil fertility, and to highway builders, helping prevent erosion. Many would not consider alfalfa to be a wildflower. However, adopting a definition from *Wildflowers Across America*—"A wildflower is simply the flower of a plant not in cultivation"—alfalfa found in a natural area certainly qualifies. Some might think of it as a weed, but the same source dictates, "A weed is a plant out of place," a description that also doesn't quite fit naturally growing alfalfa. The seed capsule, which forms twisted coils, is most unusual, and the bright, intense purple flower, though small, is quite impressive.

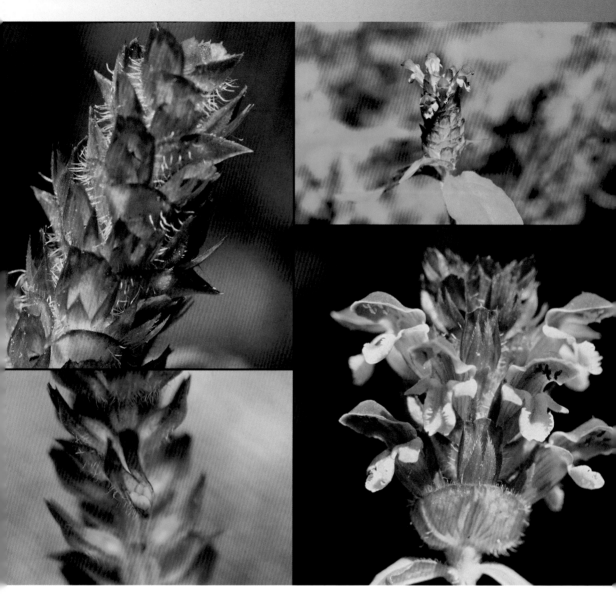

WILDFLOWERS HAVE BEEN KNOWN to treat numerous ailments, only a handful of them noted in this volume. Some reference books describe heal-all as a miracle plant that heals all diseases, thereby explaining its common name. The blossom's mouth and throat suggested curative properties for problems in corresponding human parts. Coming upon one while hiking, you will have to bend down to look into its face: the heal-all is only six to twelve inches tall. You may think you have discovered a cluster of tiny orchids, but you'll realize it's a member of the mint family when you see its square stem.

HAREBELL ✿

Campanula rotundifolia

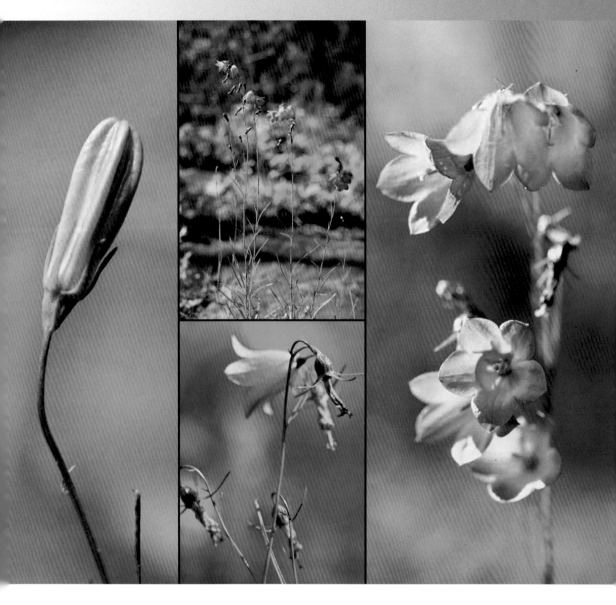

HAREBELLS GROW in rather adverse conditions, often rising out of tiny crevices in rocky outcroppings. One wonders how their weak, hairlike stems can support a three-quarter-inch blossom. I've watched bumblebees tumble as they try to enter the inverted bell, which swings and sways, sometimes bending to the ground, always managing to return to its original position. In Victorian times, when flowers were given to friends and lovers to communicate particular feelings or levels of devotion, one of the meanings associated with harebells was grief. Maybe that is why Emily Brontë included them in her moving ending to *Wuthering Heights:* "I lingered round [the graves] under that benign sky, watched the moths fluttering among the heath and harebells, listened to the soft wind breathing through the grass, and wondered how anyone could ever imagine unquiet slumbers for the sleepers in that quiet earth."

Mid-season Flowers

MARSH SKULLCAP ♋

Scutellaria galericulata

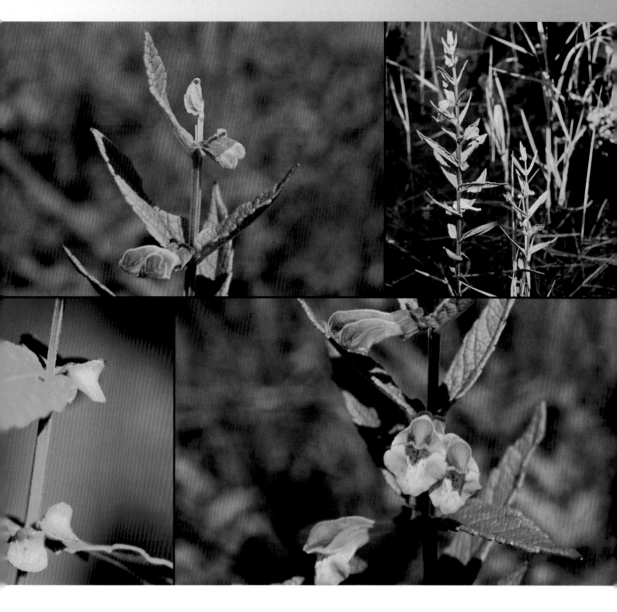

IF YOU DON'T MIND WET FEET while hiking, maybe you've seen the marsh skullcap. Its blossoms are small and insignificant, requiring wildflower "eagle eyes" to spy a hint of lavender hidden in the green foliage. Upon closer inspection, you will see that this plant has opposite leaves with flowers in each leaf axil (the angle formed by the upper side of a leaf and the stem). The flowers bloom two by two along the square stem, and their fused petals form a sculptural shape much like that of a skullcap. In the past, one of its cousins was used to treat people with rabies, earning the name *mad dog skullcap*.

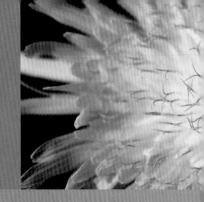

LATE-SEASON
FLOWERS

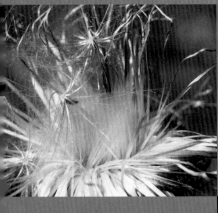

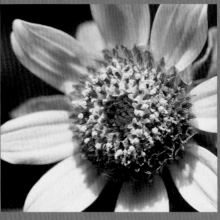

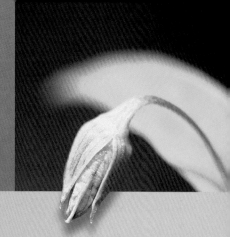

There's a nip in the crisp morning air, and Mother Nature has been working overtime, encouraging the late bloomers to set their seeds for next season's repeat performance.

COMMON YARROW
Achillea millefolium

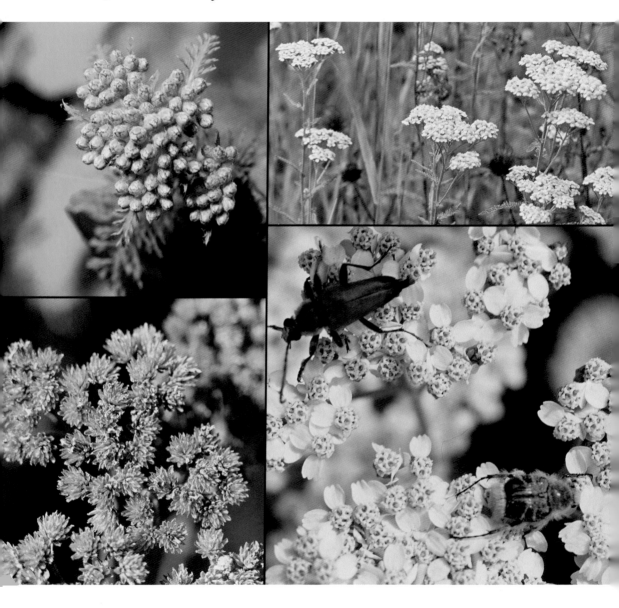

YARROW HAS BEEN CREDITED with treating many health problems, including hemorrhoids, toothaches, diabetes, cramps, hypochondria, sprains, colds, ulcers, earaches, balding, and diseases of the liver, kidney, and lungs. It was also employed during the American Civil War as a blood-clotting agent. It has been used to make vinegar and as a flavoring for soft drinks and liqueurs. Hanging it in a cradle was supposed to discourage baby-stealing witches. Even with such a long list of uses, its best attributes in my opinion are feathery fernlike leaves and the multi-flowered head of the long blooming yarrow. Yarrow might be one of the plants Mourning Dove (Christine Quintasket) was thinking about when she wrote, "everything on the earth has a purpose, every disease an herb to cure it, and every person a mission. This is the Indian theory of existence."

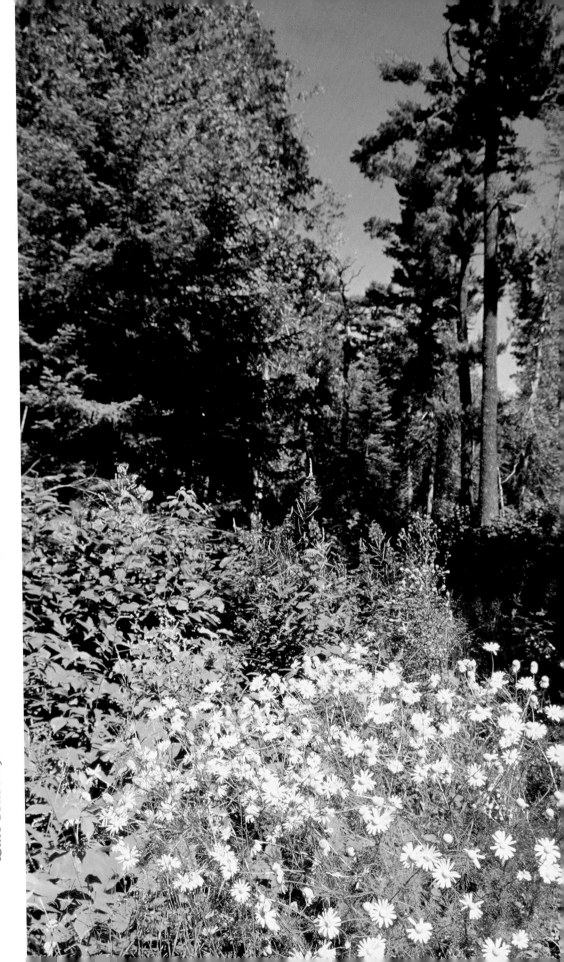

SCENTLESS CHAMOMILE
Tripleurospermum inodurum

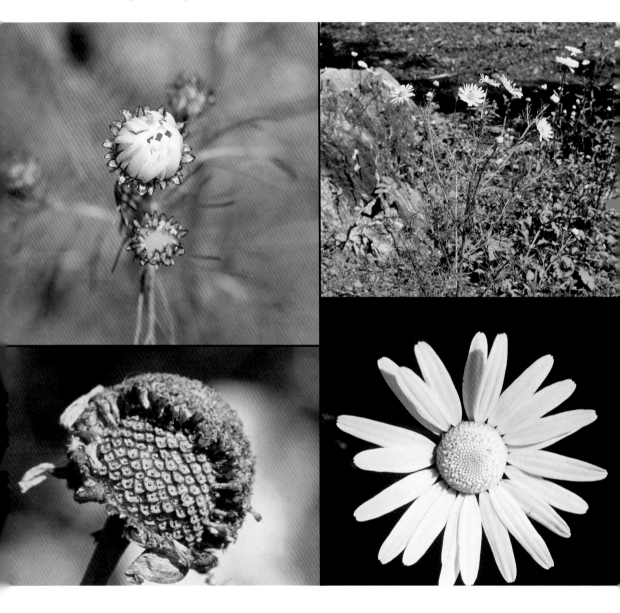

PERHAPS YOU HAVE ENJOYED a cup of chamomile tea as a soothing finish to a hectic day. As far back as the 1700s, chamomile was said to produce sweat, provoke urine, quench thirst, and abate fever. Do not be misled. The Boundary Waters scentless chamomile (pictured) is a different species than the chamomile, *Matricaria recutita,* used to make your favorite tea. I prefer to emphasize the physical attrib-

utes of our chamomile, *Tripleurospermum inodurum.* You might think of it as a dressed-up daisy. The light green leaves are finely cut into hairlike segments, and the flower stems develop from different points on the upper stalk, forming a rounded top of blossoms. The mayweed looks very much like the scentless chamomile, but it's shorter and strongly scented.

TOWER MUSTARD

Arabis glabra

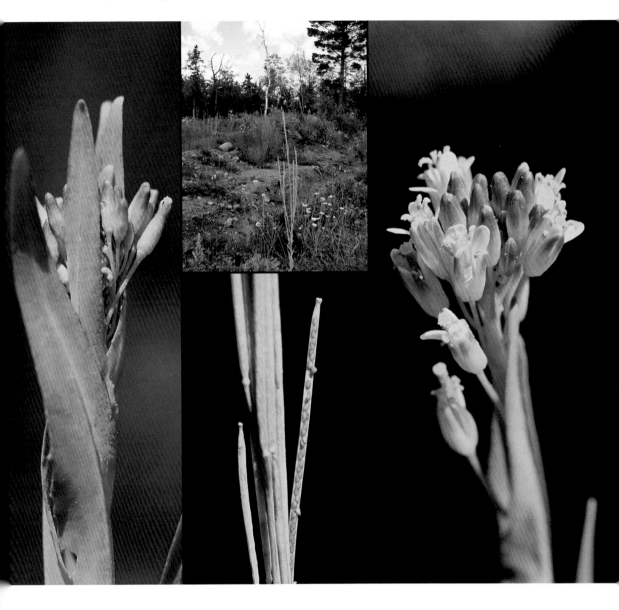

TOWER MUSTARD is probably not on anyone's list of ten favorite wildflowers. In fact, most guides ignore this member of the mustard family altogether. Since this book is about the seasons of wildflowers, the tower mustard deserves attention for its most impressive final show. You're in for a treat if tower mustard grows near your favorite hiking trail: watch it "build" its tower for many weeks until it reaches a height of about four feet. The four-petaled blossoms "ride" up on the top of the stems. For something truly striking, observe the seeds all lined up snug in the very slender stalk.

Late-season Flowers

BROAD-LEAVED ARROWHEAD ❧
Sagittaria latifolia

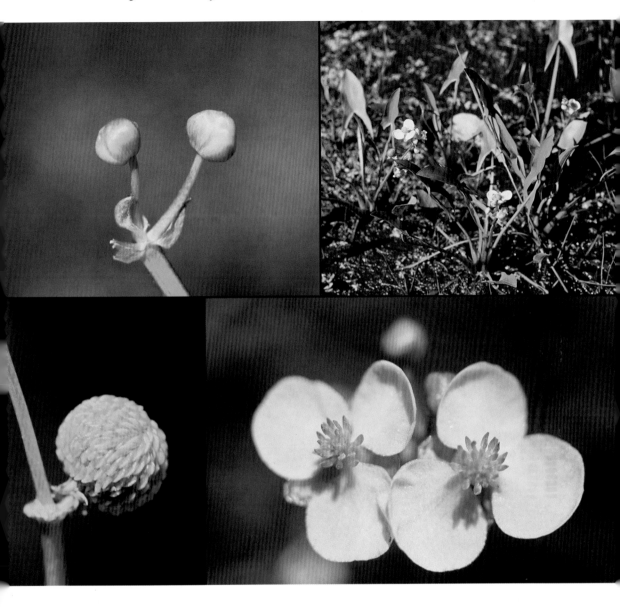

AN ANNUAL LATE-SUMMER HIKE to a pond where arrowhead likes to grow has never been a disappointment. For some plants, low rainfall means few blossoms, but the arrowhead, an edge-of-pond-dweller, doesn't face that problem. Its common name describes its leaves, some long and thin but most quite broad, always in the shape of an arrowhead. Another common name is duck potato, which seems appropriate: ducks and other water-loving animals enjoy eating the underwater tubers. If you are ever invited into a muskrat's home, you'll probably find a cache of arrowhead tubers stored for winter dining pleasure. American Indians sliced and dried the tubers to fill a major portion of their food supply; Lewis and Clark referred to them as "wappa-too" in their journals.

HORSEWEED ℬ

Conyza canadensis

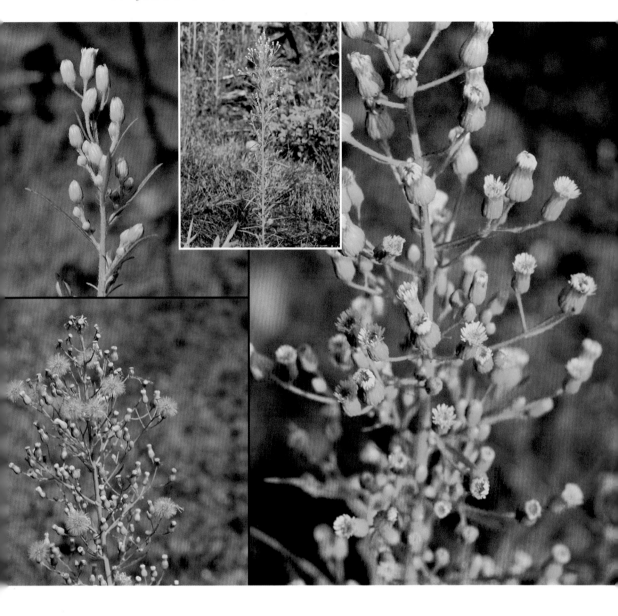

HORSEWEED LIVES UP to its common name: it is definitely a weed, and in its fruiting season it resembles a horse's tail. As with many wildflowers, a solitary plant is not too impressive; however, a patch of horseweeds makes for an interesting sighting. The blossoms— cuplike, one-eighth inch long, with miniature upright rays—would never impress. Newcomers to this plant might wait for it to burst into bloom, only to discover that it has already done so: its rays never spread out to a disk-shaped blossom.

PEARLY EVERLASTING ℬ

Anaphalis margaritacea

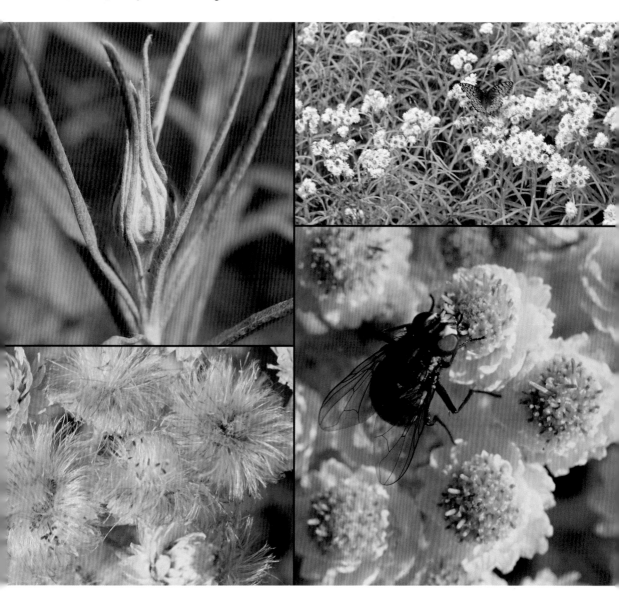

UPON HEARING THE NAME and looking at this wildflower when it's just beginning to bloom, you probably will never forget it. The small, white, ball-like flowers will remind you of pearls atop a stem. Its scientific name, *margaritacea,* means "pearly." Harvest this wonderful flower from your garden to use in dried fall bouquets or to tie with a red ribbon on your special Christmas packages. Pearly everlasting has been used by American Indians to cure many health problems, but its most unusual reported use is that, if chewed, it made the person want to sing. Perhaps we should let some choir directors in on this secret.

HOARY ALYSSUM

Berteroa incana

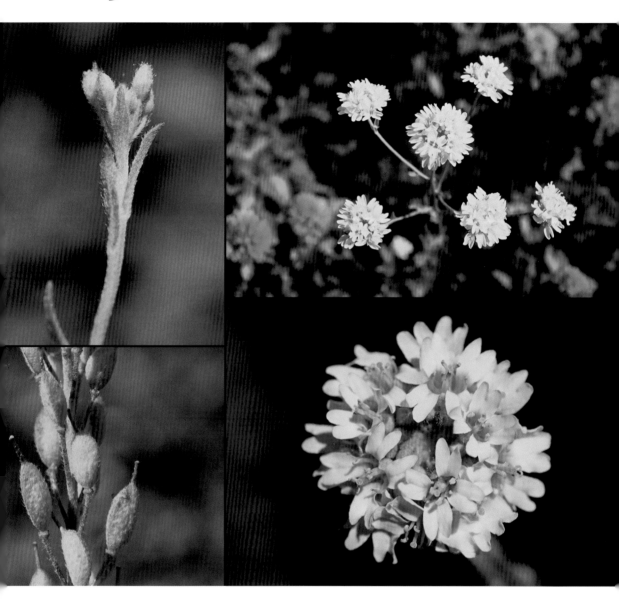

THE FOUR PETALS of the hoary alyssum's tiny, white flowers are so deeply notched that, unless you take a closer look, they almost appear to be eight petaled. The flowers form small clusters of blossoms, looking like miniature snowballs perched on top of a one- to three-foot stem that is very strong and upright, never weak-kneed. Look for hoary alyssum along the edge of the road or in any dry, gravelly area. Its common name describes the grayish white hairs that cover the entire plant—a theme that continues into its final season, when hairs cover its seed capsules.

Gaultheria procumbens

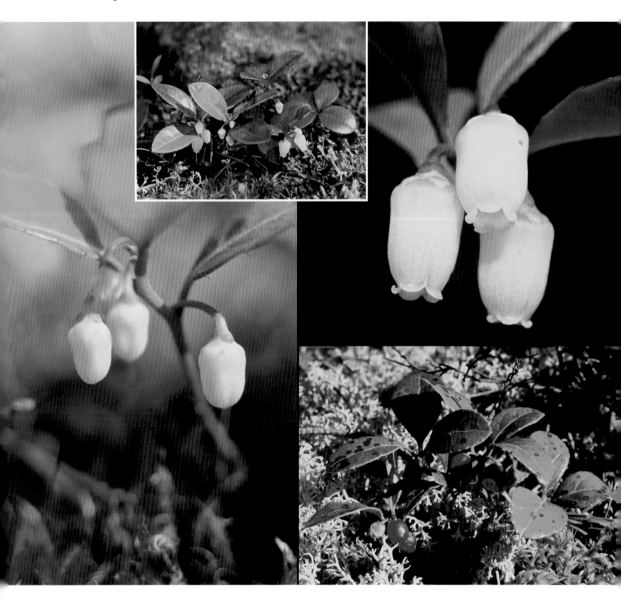

CRUSH THE BRIGHT RED BERRIES of the wintergreen to remind you of the scent of your favorite childhood chewing gum. The entire plant exudes a strong odor of oil of wintergreen (methyl salicylate). The wintergreen, a handsome plant with bright, shiny, evergreen leaves, is often found growing with the light gray and green, multi-branched reindeer moss, a beautiful contrast. The bell-like flowers resemble the blueberry or leatherleaf bells in the early spring. American Indians have made tea from wintergreen leaves to relieve pain from rheumatism.

Late-season Flowers

VIRGIN'S BOWER
Clematis virginiana

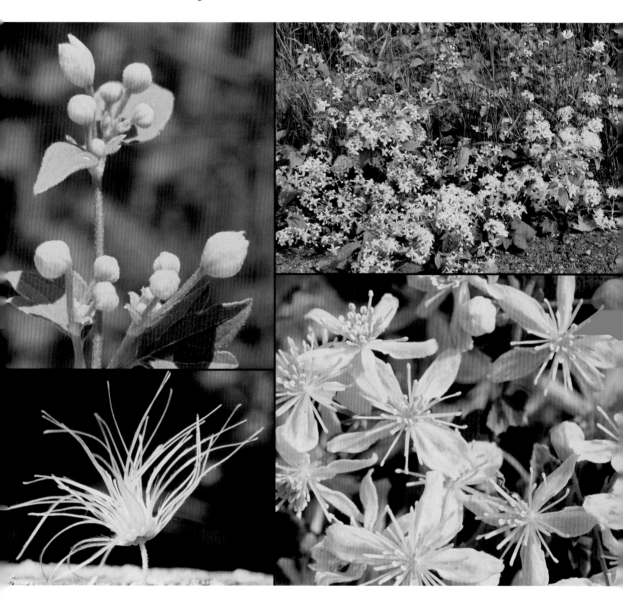

OLD MAN'S BEARD is another common name for virgin's bower, referring to the seed-forming season, when circular, feathery plumes cover the plant. What appears to be a four-petaled flower is actually one made up of four petal-like sepals and many stamens. This August bloomer winds and climbs over other plants, sometimes forming a heavy drapery of leaves. It is also known as traveler's joy, providing the weary with protection from sun or rain. The mellow, cream-colored flowers (sometimes considered greenish white) may appear from a distance to be an early snowdrift. Speaking of snow, did you know that all of the wild-flowers in this book can survive frigid -40°F temperatures with little difficulty? A thick blanket of snow usually provides protective insulation from the piercing, cold north wind.

PIPSISSEWA ℬ

Chimaphila umbellata

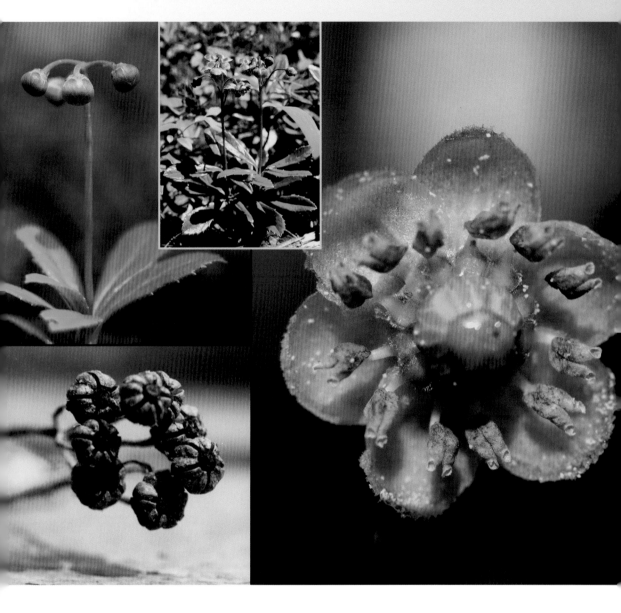

ALL SEASONS OF THE PIPSISSEWA are not to be missed. The relatively large, smooth, pink buds seem to promise good things to come. The waxy, pink, five-petaled flowers hang their heads and beckon you to get way down for a good look. They do not disappoint, with many prostrate stamens and in the center a stunning, lime-green pistil. The pipsissewa's whorled, tiered, shiny, leathery, evergreen leaves with their sharp teeth are considered by some to be the most beautiful of wild-flower foliage. Return later in the season to find that the fruit appears as a dried, brown cluster of miniature geometric flowers.

FIREWEED

Epilobium angustifolium

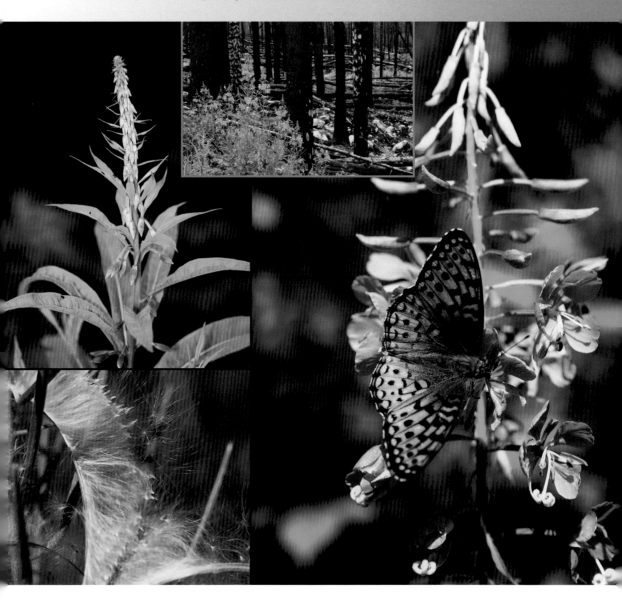

SURPRISE, SURPRISE: one of the first plants to appear after a fire is the fireweed. Pass by a patch of blooming fireweed on a windy day, and you will not question its common name: the flower spike's shape creates an illusion of tongues of fire, although of course real flames lean toward a much warmer tone. Fireweed moved into the bombed-out areas of London after World War II, providing a beautiful ground cover in the midst of disaster. The bright magenta seed capsule offers one more pleasure at season's end. If you're lucky enough to see the capsule burst open, you'll understand how important the wind is in seed distribution: it can carry the fine, bristly, hairy parachutes for quite a distance.

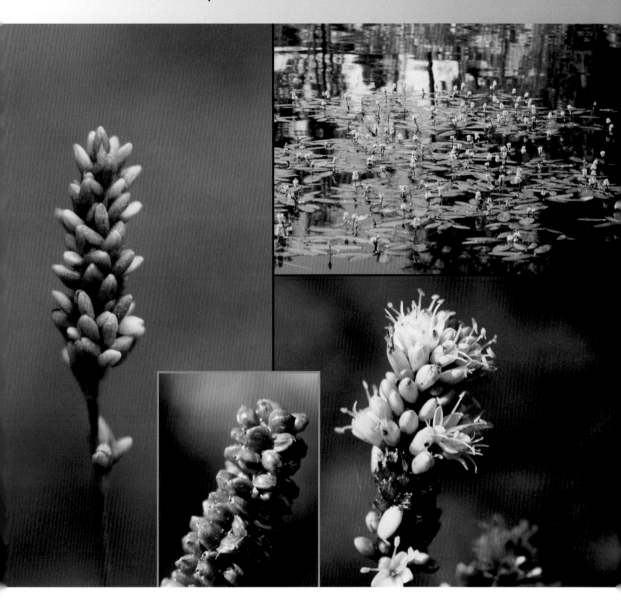

WHEN THE SMARTWEED is in bloom, the inflorescence includes buds, flowers, and seedpods. Even though only a few of the very small blossoms are in full bloom at the same time, the pink buds and pink immature seedpods make the cluster quite impressive. Parts of this plant are good enough to eat: waterfowl feast on the seeds, and American Indians once ground them into flour. If ever a scene in nature could call to mind an Impressionist painting, I suggest the above photo of water smartweed to be reminiscent of Monet's *Water Lilies*.

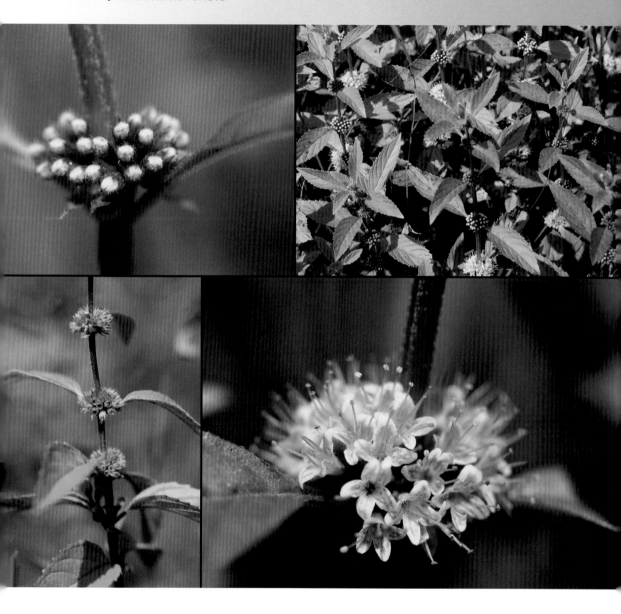

MINT IS RECOGNIZED and enjoyed by young and old for flavoring many items, including chewing gum, chocolate, jelly, and juleps (like those served at a friend's cabin on Kentucky Derby Day). One small animal doesn't like the smell of mint: the mouse. Use this bit of information to your advantage: scatter mint and send the critters scurrying away. Identifying a member of the mint family is elementary when you realize they all have square-shaped stems. Of course, the easiest way to identify wild mint is to crush a leaf and let your nose be the judge. If you grow some in your garden, be sure to plant where you can contain it, or you will have a field of mint in just a few years. Imagine: at one time, the familiar Wrigley Company grew over fifty square *miles* of mint to flavor its products.

BULL THISTLE

Cirsium vulgare

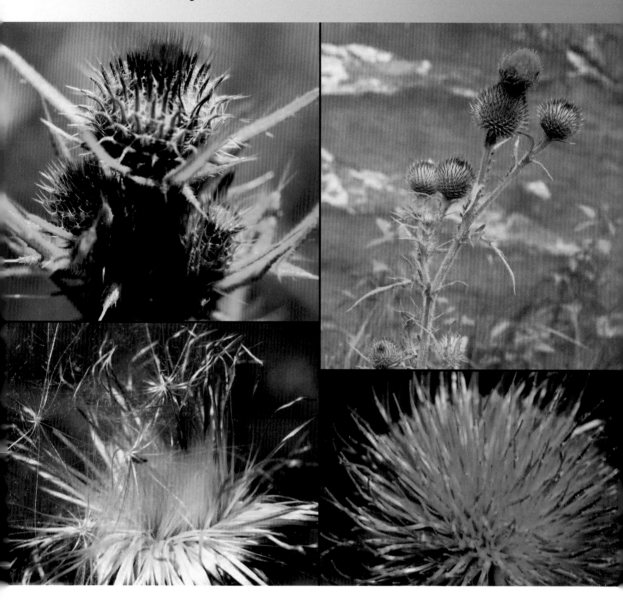

THE BULL THISTLE—one of the biggest, prickliest, strongest, tallest thistles—is also one of the most beautiful plants, from its bud nestled in mostly vicious prickles to its crowning glory of large, shocking pink flower puffs. One of the thistle family's greatest gifts is its seed to be enjoyed by small birds, especially goldfinches. On my thistle feeder, as many as thirteen goldfinches vie for seeds, ample reason to appreciate this plant. Did you know that goldfinches do not build their nests until thistle down is mature so they can use it as a lining? Thistle down was even used in quilts to keep past generations of Americans warm.

Late-season Flowers

JOE PYE WEED ❧

Eutrochium maculatum, Eutrochium purpureum

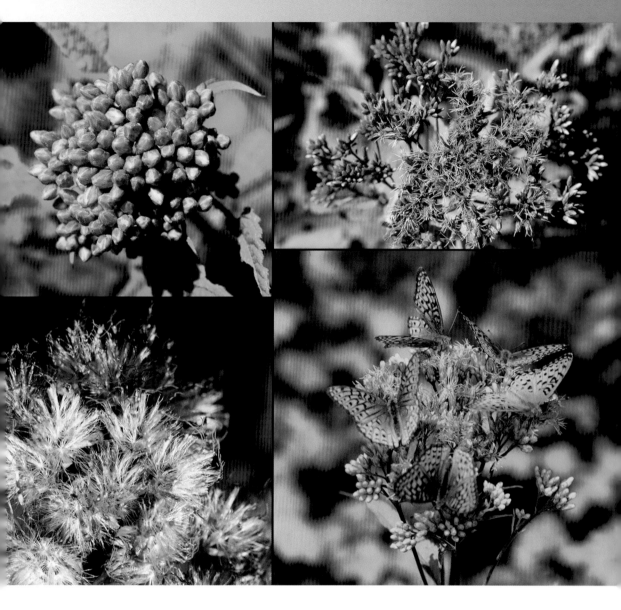

TRAVELING MEDICINE MAN Joe Pye used this wildflower to treat many ailments, from inflamed joints to typhoid fever. He must have enjoyed a certain degree of success: the plant has carried his name for more than two hundred years. This flower matures when many of its summer-blooming neighbors are fading. An especially welcome, fresh addition to nature's seasonal bouquet, it introduces a deep, mauve hue to the warm autumn color palette. The difference between the two species of Joe Pye weed is obvious: the *maculatum* is flat on top, while the *purpureum* is dome shaped. When looking through the lens of my camera and seeing five butterflies fluttering on the Joe Pye weed, I must admit to being more impressed with the butterflies than the flower. This view reminded me of the words of French poet Écouchard Lebrun: "The butterfly is a flying flower, the flower a tethered butterfly."

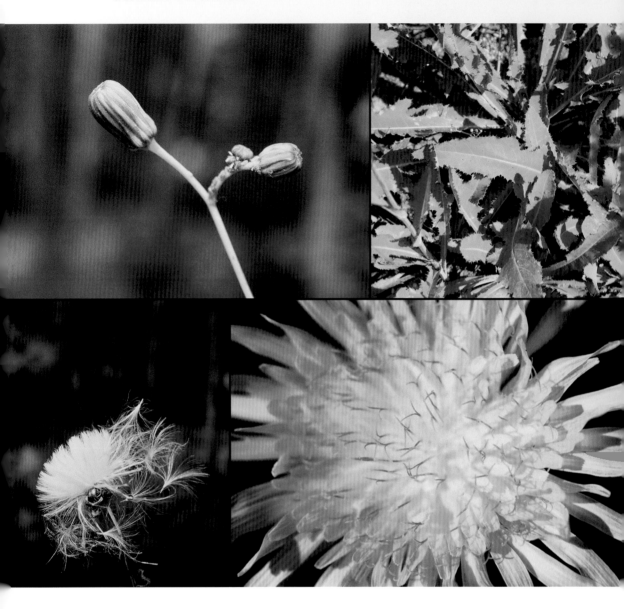

AT FIRST GLANCE, the sow thistle may appear to be a dandelion on steroids. The flower head is similar, but the sow thistle stands three to four feet tall. It grows along roadsides and in waste places, its juice is milky, and the plant spreads by rootstocks forming large patches. The sow thistle seems to be a sun worshipper, turning toward it throughout the day: in the morning facing east, at noontime turning south, and ending each day facing west. Animals react differently to it as a food source: rabbits, pigs, sheep, and goats enjoy it, but horses will not eat it.

219

Late-season Flowers

JEWELWEED ♋

Impatiens capensis

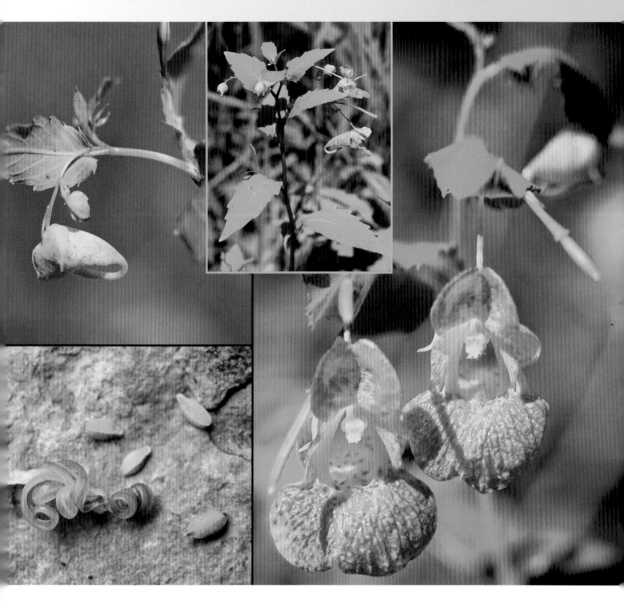

JEWELWEED COULD HAVE EARNED its common name because the blossoms dangle like earrings from the plant. Some say dewdrops reflect on the blossoms like jewels. Another common name, *touch-me-not*, refers to the mature seedpod that literally explodes in your hand as it springs open to disperse its seeds.

Hummingbirds, whose long bills have evolved to be the jewelweed's primary pollinator, thrive on the nectar from these flowers. You'll be happy to find the jewelweed, too, if you have the misfortune to end up in a patch of poison ivy: simply rub its fresh leaves or crush its stem on the irritation for some relief.

LARGE-LEAVED AVENS

Geum macrophyllum

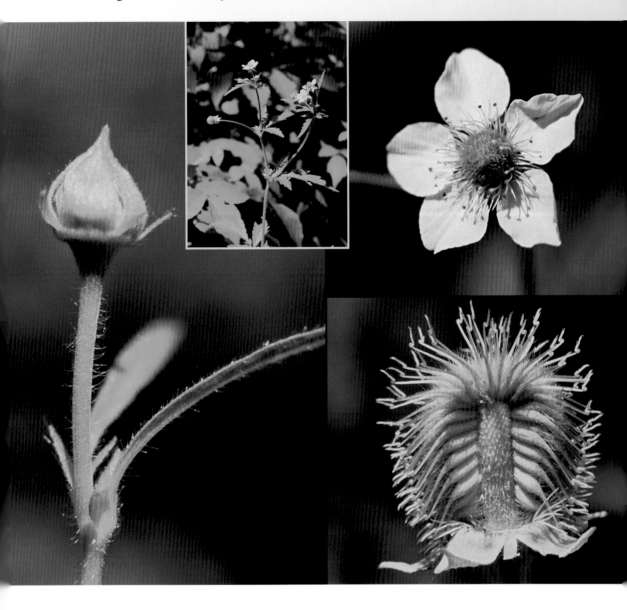

NO MATTER HOW ATTRACTIVE the bright, yellow flower of the avens is, its seeds turn it into the most unwelcome wildflower guest I have. I watch the avens carefully, and when the seeds have developed, off they go to my trash pile. Each one that escapes my clippers is sure to hook onto my trousers and cling like a piece of Velcro. It's been said that Velcro's inventor was inspired by seeds clinging to his clothing. He might well have encountered a patch of yellow avens: look closely at the hooks on its seeds.

223

BUTTER-AND-EGGS

Linaria vulgaris

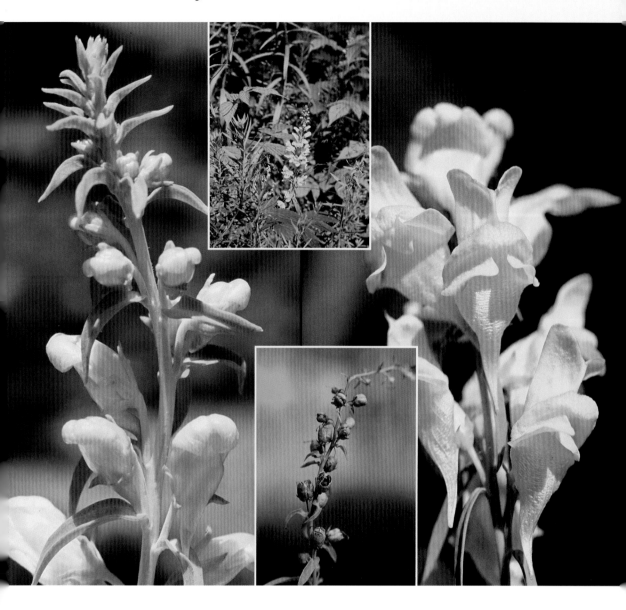

WILDFLOWERS ARE GIVEN different common names in different geographical areas, which can make for some confusion. *Linaria vulgaris* is no exception: it has thirty recorded folk names, including dead-man's bones. My two favorites are butter-and-eggs and toadflax. Native to Europe, toadflax was used as a medicine for the bubonic plague. Along the way, *bubonium* was misspelled as *bufonium*; *bufo* in Latin means "toad." A glance at the flower in bloom will show there's no need to explain the origin of the name *butter-and-eggs*. Children, young and old, like to squeeze the blossoms (behind the lips), perhaps trying to make the toads "croak."

FRINGED LOOSESTRIFE ❦

Lysimachia ciliata

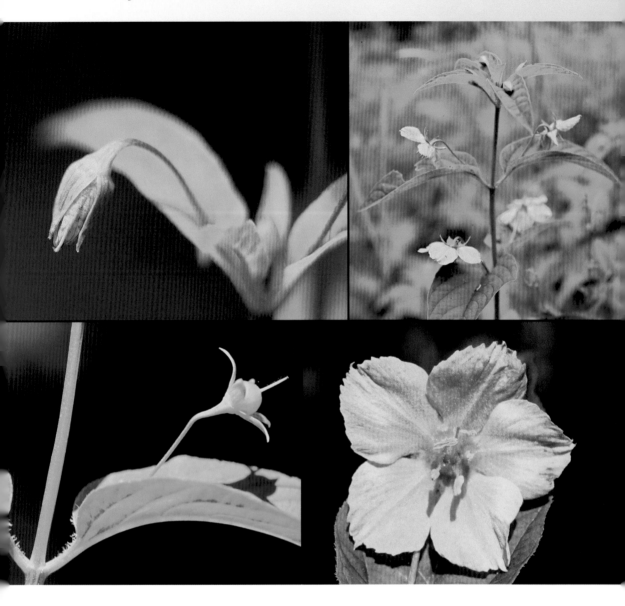

YELLOW SEEMS TO BE one of nature's favorite colors, and fringed loosestrife is a shining example of this hue. One unique feature displayed by this plant is that its blossoms hang upside down. Perhaps loosestrife is shy or wants you to search for its most beautiful attribute: a muted ruby red center in its blossom. The *fringe* in fringed loosestrife is found in curly, white hairs on the stalks of the leaves, visible on the seed photo above. The loosestrife is a friend to bees, supplying oil and pollen to feed their larvae.

COMMON MULLEIN
Verbascum thapsus

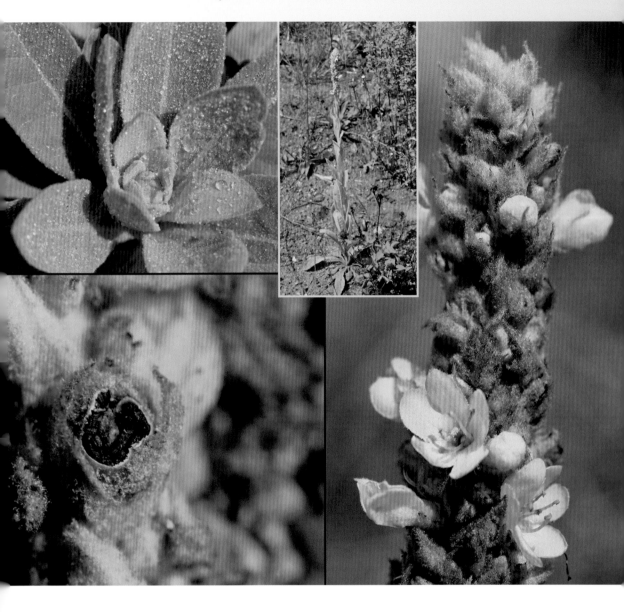

FEW FLOWERS ANNOUNCE their presence so beautifully a year before any blossoms appear as does the common mullein. In that first year, it grows into a pale, soft green, velvety "rose" made up entirely of leaves that hug the ground. In its second year, a very tall, straight flower stalk appears. The mullein's upturned leaves guarantee that every droplet of moisture is directed to the base of the plant. The mullein has been adopted for diverse purposes through time. Roman soldiers dipped the sturdy stems in tallow for use as torches, for example. The rough leaves were used by women to brighten their cheeks and were put in shoes because people believed the slight irritation they caused would improve blood circulation. Mullein was also used by witches and warlocks in love potions or in brews to charm against demons.

YELLOW LOOSESTRIFE ℬ

Lysimachia terrestris

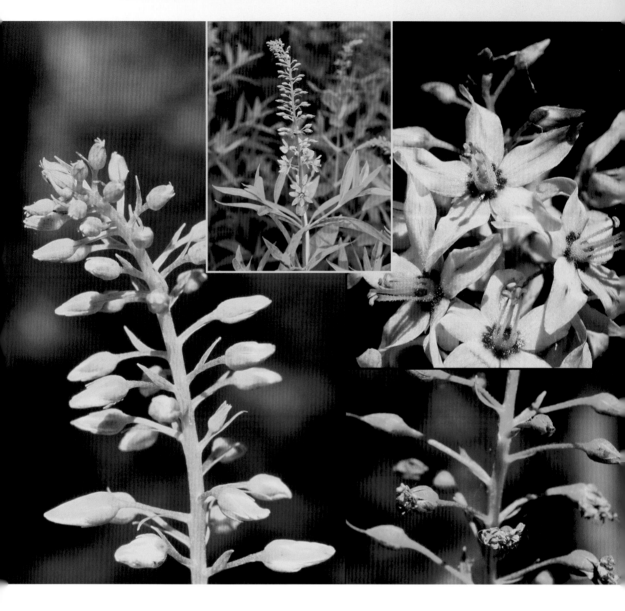

YELLOW LOOSESTRIFE is also known as swamp candle, a perfect common name for this wildflower that grows in wet places and looks a bit like, well, a candle. Its yellow starlike flowers are arranged in a tapered spire, while its leaves are opposite and narrowly lance shaped. You might never see this plant unless you are accustomed to walking around in wet, boggy habitats, though it does usually accommodate such intrepid hikers by lifting its candles above the surrounding foliage. Both the yellow loosestrife and the fringed loosestrife are members of the same family and, interestingly, both have a warm red center in the middle of lemon yellow petals. Would you call this a family resemblance?

SULPHUR CINQUEFOIL

Potentilla recta

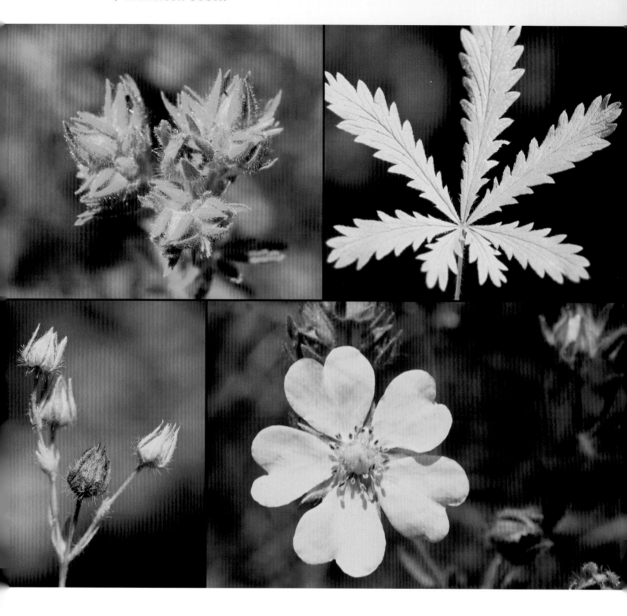

THE SULPHUR OR ROUGH-FRUITED cinquefoil has three commendable characteristics: the petals are indented along the outer edge, making them appear heart-shaped; its pale, creamy color is unlike the other, much brighter, golden yellow cinquefoils; and the narrow leaves are coarsely toothed, adding an interesting texture in the wild or in a wildflower garden. *Cinquefoil* means "five-leaved," but don't be misled: what appears to be five (or seven) leaves is only one leaf deeply cut into many parts. Some associate the leaves with the hand of a priest giving a blessing; perhaps it follows that in its past cinquefoil was also used to ward off evil spirits.

BEGGAR-TICKS ⚘
Bidens cernua

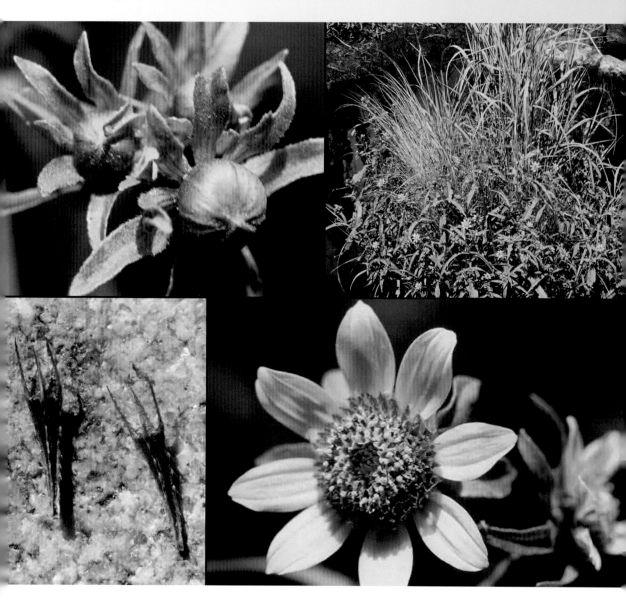

LOOK FOR BEGGAR-TICKS blooming in the bottom of a roadside ditch or other wet areas in late summer. The fresh golden blossoms are a welcome sight, but beware of this plant when the seeds are set. *Sticktights* is another common—and certainly descriptive—name.

The seeds, shaped like a small pitchfork with barb-bearing prongs, stick tight to anything that touches them. Those familiar with marigolds might notice a resemblance: this plant is sometimes referred to as *bur-marigold*.

Late-season Flowers

TANSY

Tanacetum vulgare

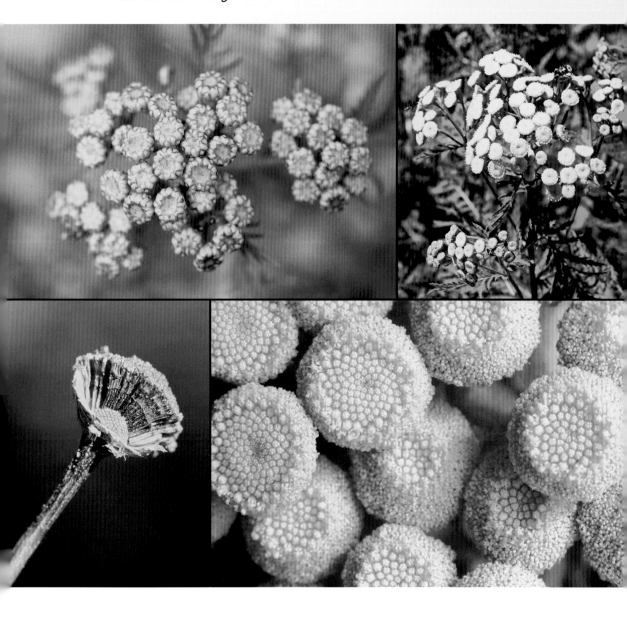

WHEN THE TANSIES ARE BLOOMING, you can't help but find them. The large yellow clusters of buttonlike flowers appearing on the terminal of three- to four-foot-tall stalks will grab your attention, and you'll also smell the strongly scented leaves. If you are wondering what the leaves taste like, don't even think about it: one source suggests medicinal tea made from the leaves is worse than the disease itself. On the other hand, an old custom worth repeating is that cakes called *tansies* were eaten at Easter. Flavored with young tansy leaves, they were a reminder of the bitter herbs eaten by the Jews at Passover.

GOLDENROD ℬ

Solidago spp.

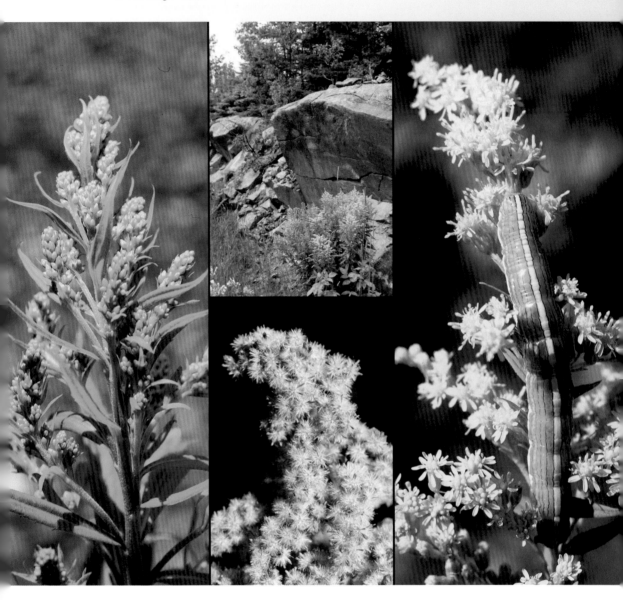

THE GOLDENROD'S BRIGHT GOLDEN PLUMES add a warm glow to the autumnal landscape just as other plants are ending their cycle and fading into beiges, rusts, and browns. Though the goldenrod does not offer a generous supply of nectar, the bees seem to sense it is one of the season's last sources. Be wary when approaching the goldenrod: the bees have the advantage in numbers—I've counted over twenty on a single plume. In earlier times, goldenrods were used to make dyes; the leaves were incorporated into teas and wines and even witches' potions. How fortunate that the goldenrod blooms in time for Halloween. Did you notice the hungry caterpillar, camouflaging itself by following the vertical stem?

CREEPING BELLFLOWER

Campanula rapunculoides

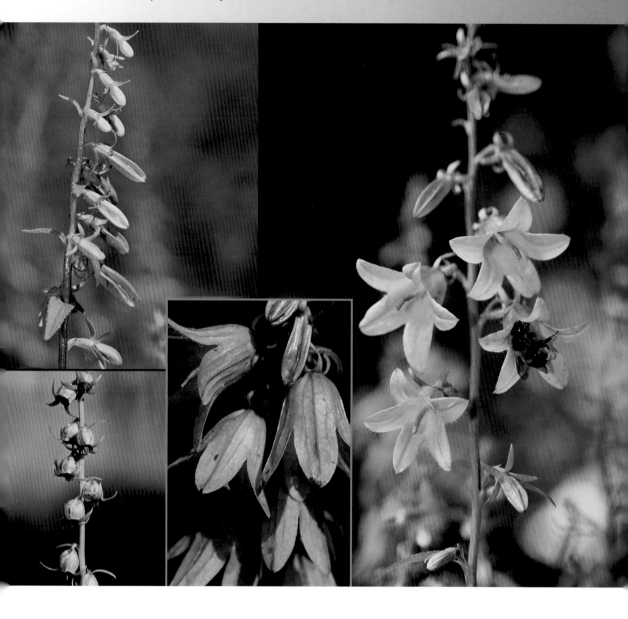

IF ALL OF NATURE'S FLOWERS shaped like bells could ring, the wilderness would be a noisy place. One of the showiest is the tall (two- to three-foot) blue creeping bellflower. Another common name for this plant is European bellflower, strongly suggesting that it was introduced to the United States from Europe, as were many of our wildflowers. Some immigrants brought seeds unknowingly hidden in their trouser cuffs, some carried them with feed for their animals, and some tucked envelopes of seeds from favorite flowers in their steamer trunks to beautify their gardens in the New World. This wildflower continues the bell theme even in its final season, when its seeds develop in small, bell-shaped capsules.

CANADA THISTLE

Cirsium arvense

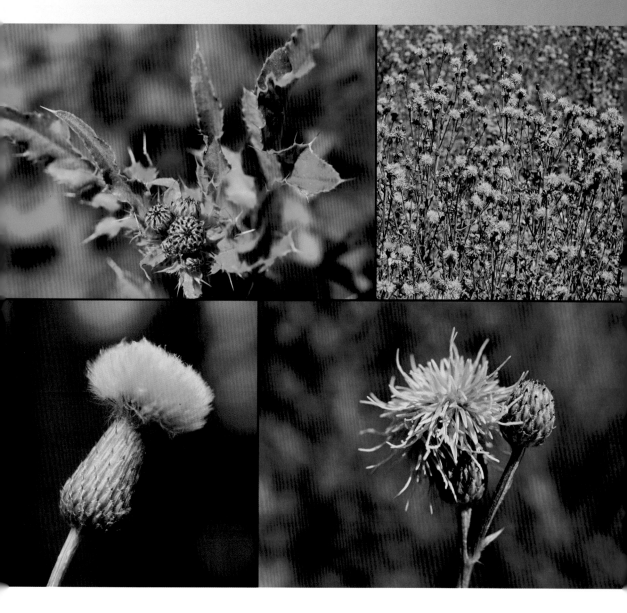

SOME SAY THE CANADA THISTLE is the worst weed of the entire United States, lacking even a single virtue. Countries have passed laws to try to eradicate this plant. Maybe even God referred to the Canada thistle when he told Adam, "Cursed is the ground because of you. . . . Thorns and thistles it shall bring forth to you." Butterflies and bees might disagree with this assessment. And even we must ad-mit that a patch of blooming Canada thistles along the roadside provides a bit of beauty—its fragrance simply an added bonus. Thistles are revered in Scotland because they helped the army in defending the country: when the enemy took off their shoes for a quiet sur-prise attack, they stepped on the thistles and cried out in anguish, ruining their surprise.

HEMP NETTLE 🌿

Galeopsis tetrahit

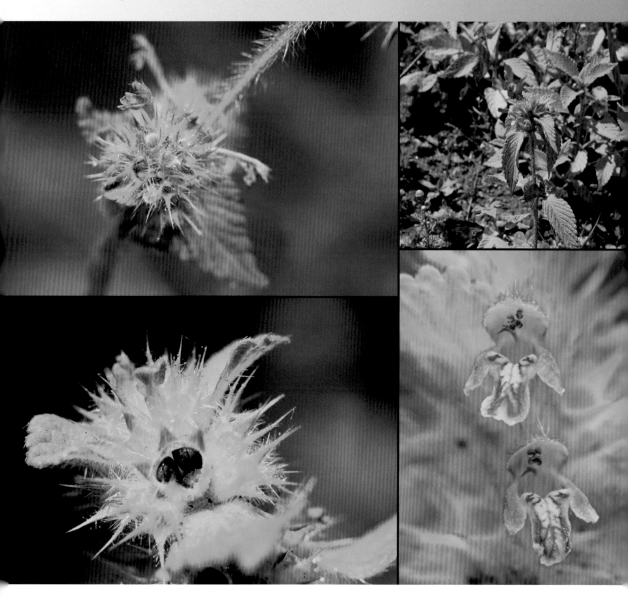

HEMP NETTLE FLOWERS are so small and insignificant that most people don't notice them or talk about their quiet beauty. When you find one, look closely and you'll see four hairy stamens and a single pistil inside each beautiful blossom. Surely you recognize the stinging nettle as much as you do poison ivy for obvious reasons: do not touch! In contrast, the hemp nettle offers a beautiful flower and doesn't sting. Though they belong to different families (stinging nettle—the nettle family; hemp nettle—the mint family), to confuse us they both carry *nettle* in their common names. Shakespeare wrote of nettles in *Hamlet,* but he no doubt was referring to the hemp nettle. Can you imagine the stinging nettle used with other wildflowers in a garland?

*There with fantastic garlands did she come,
of crowflowers, nettles, daisies.*

SPOTTED KNAPWEED

Centaurea stoebe

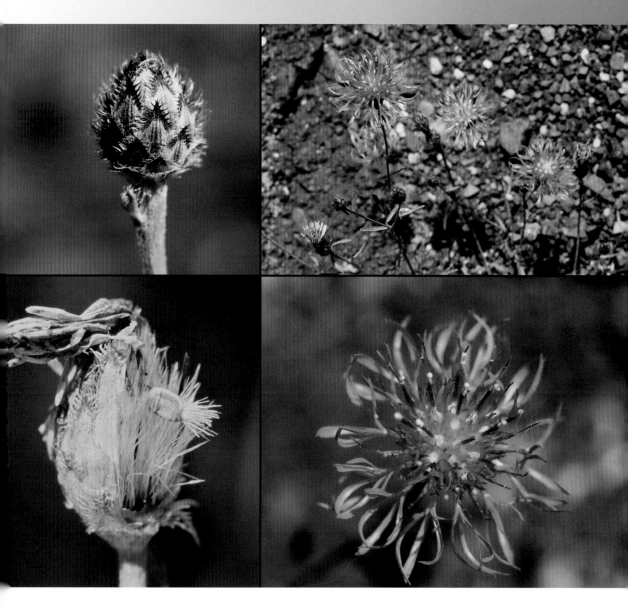

KNAPWEED IS AN INVASIVE PLANT that many love to hate. It is very aggressive, crowding out other plants and releasing a toxin into the soil so they cannot survive. The *spot* in its name refers to a black tip on the bracts (leaflike structure at the flower's base). A single-stemmed plant can produce as many as one hundred shocking pink to bright lavender flowers; its grayish and silver green, deeply lobed leaves are most attractive; and the bud deserves recognition for its unusual pattern and texture. Still, it's considered a noxious weed by many state agricultural departments, one worthy of eradication.

LINDLEY'S ASTER ✿
Symphotrichium ciliolatum

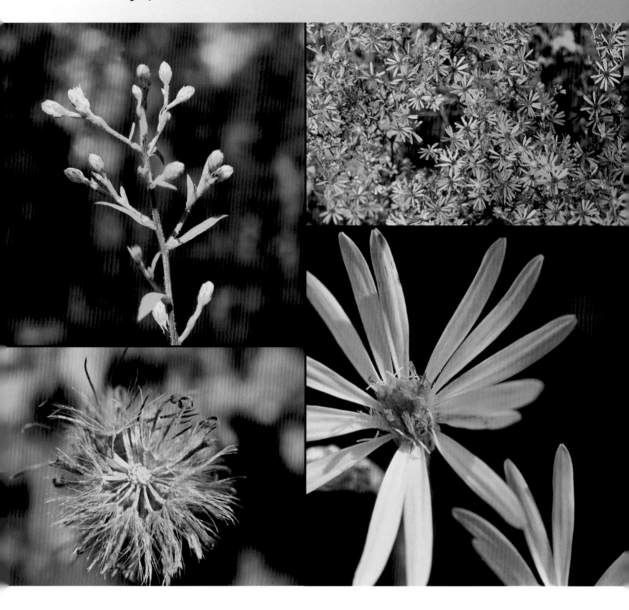

SOME ASTERS seem to steal the show from others (sounds like Hollywood), and Lindley's aster fits the bill. It always seems to have more outer ray florets (a single flower, usually of a composite head) and more intense color than other asters, and, best of all, it blooms into October. About one hundred fifty species of wild asters are native to North America, and six hundred exist worldwide. To identify a particular species requires a good deal of time and care. My botanist friend and I have concluded that this aster is Lindley's, and we hope you agree. The disk can start out yellow and then turn magenta, purple, or a rusty red and, finally, brown. What a show! What a star!

Late-season Flowers

LARGE-LEAVED ASTER ✽

Eurybia macrophylla

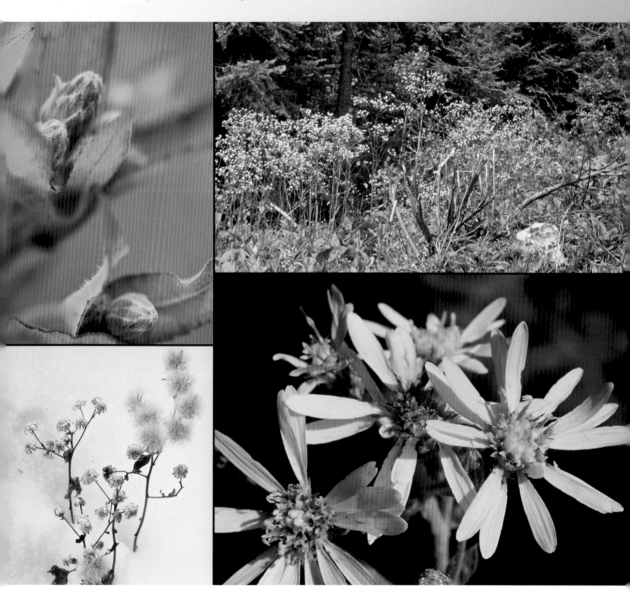

TRUE TO THEIR NAME, asters are the "stars" of the fall bloom, probably because they are so prolific—blooming, blooming everywhere. In fact, they bloom so late in the season that many endure a few snowfalls while still holding their seeds. The aster might have learned that dropping its seeds on crusty snow could scatter them a greater distance. More than once I've been fooled on a springtime hike, wondering what is blooming ahead of me on the trail, only to discover the outer carcasses of last season's seed capsule, bleached by the bright winter sun and looking very much like small white flowers in the distance (as pictured above).

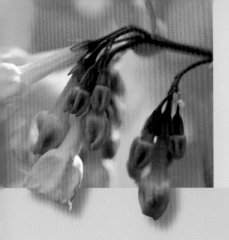

WILDFLOWER CHALLENGE

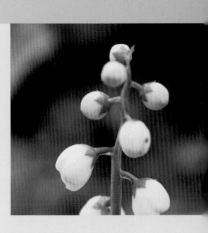

MY QUEST to photograph the seasons of the wildflowers has come to an end. I now challenge you to continue the search. Here you will find one season of twenty more wildflowers of the Boundary Waters region. You are invited to find and photograph their other seasons:

 a. "as seen while hiking"
 b. bud
 c. plant
 d. full flower
 e. seed

Make note of dates or locations where you find these flowers in their other seasons. May your wildflower journey be as rewarding and enjoyable as mine has been.

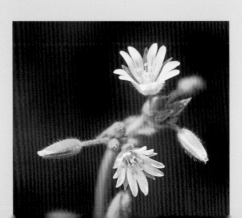

WHITE BANEBERRY ℬ

Actaea pachypoda

Doll's eyes is a common name for the white baneberry, which is almost a twin for the red baneberry.

a. _____

b. _____

c. _____

d. _____

e. (PICTURED) _____

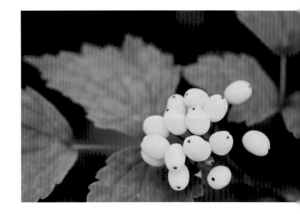

BLADDERWORT ℬ

Utricularia vulgaris

This plant's underwater bladders collect minute water life for nutrition.

a. _____

b. _____

c. _____

d. (PICTURED) _____

e. _____

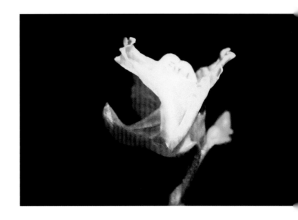

VIRGINIA BLUEBELL

Mertensia virginica

This bluebell offers clustered, trumpet-shaped blossoms on nodding stems. Leaves are oval and hairless, distinguishing it from the northern bluebell.

a. _____

b. _____

c. _____

d. (PICTURED) _____

e. _____

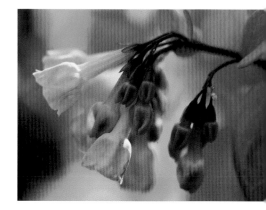

BUCKBEAN

Menyanthes trifoliata

Buckbean thrive in peat bogs and shallow water areas.

a. _____

b. _____

c. _____

d. (PICTURED) _____

e. _____

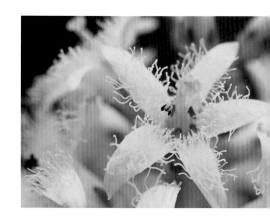

BURDOCK

Arctium minus

Burdock displays handsome "elephant-ear" leaves but is detested for its clinging burrs.

a. _____

b. _____

c. _____

d. (PICTURED) _____

e. _____

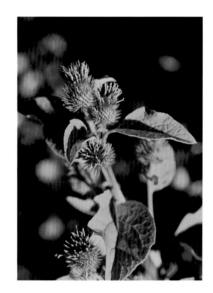

CHICKWEED

Cerastium vulgatum

If you don't use herbicides, you may find a few chickweeds in your own backyard.

a. _____

b. _____

c. _____

d. (PICTURED) _____

e. _____

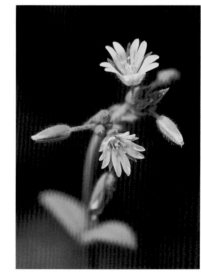

MARSH CINQUEFOIL ℬ

Potentilla palustris

This member of the rose family lives in or adjacent to quiet water.

a. _____

b. _____

c. _____

d. (PICTURED) _____

e. _____

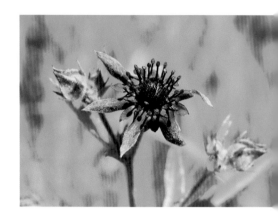

PURPLE CLEMATIS ℬ

Clematis verticellaris

The blossom never expands completely and so always resembles a bell.

a. _____

b. _____

c. _____

d. (PICTURED) _____

e. _____

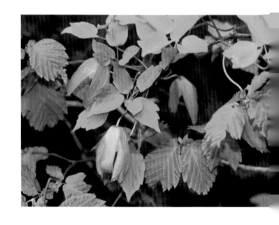

DEPTFORD PINK

Dianthus armeria

This shocking pink, one-half-inch flower dotted with white spots sits on top of a twelve- to twenty-four-inch, stiff, erect, slender stem.

a. _____

b. _____

c. _____

d. (PICTURED) _____

e. _____

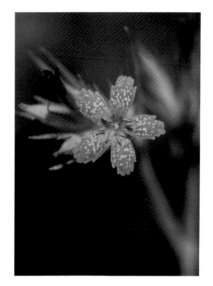

DEWBERRY ꙮ

Rubus pubescens

Looks like a raspberry but only grows to about four to eight inches tall on a trailing woody stem.

a. _____

b. _____

c. _____

d. _____

e. (PICTURED) _____

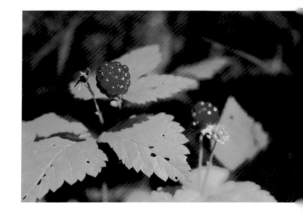

SPURRED GENTIAN ℬ

Halenia deflexa

True to its name, this gentian's corolla has four spurs. It may be found in ditches and boggy areas at the edge of the forest.

a. _____

b. _____

c. _____

d. (PICTURED) _____

e. _____

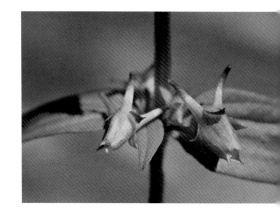

LEATHERLEAF ℬ

Chamaedaphne calyculata

This evergreen shrub is one of the first to bloom in early spring.

a. _____

b. _____

c. _____

d. (PICTURED) _____

e. _____

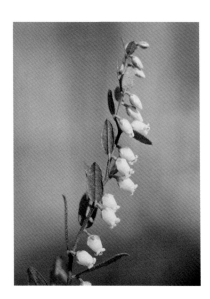

LUPINE

Lupinus spp.

This species is a garden escapee. It is invasive, crowding out our native wildflowers.

a. (PICTURED)

b.

c.

d.

e.

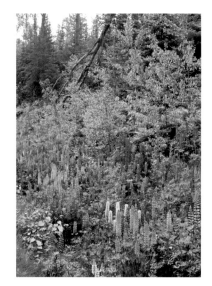

CORALROOT ORCHID

Corallorhiza maculata

This plant cannot produce food from sunlight and instead takes nutrients from decaying organic matter.

a.

b.

c.

d. (PICTURED)

e.

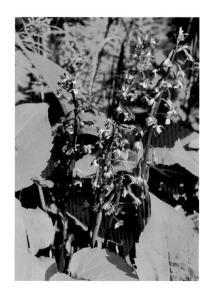

HOOKER'S ORCHID ℬ

Platanthera hookeri

Often overlooked, this orchid is one of the green wildflowers camouflaged on the forest floor.

a. _____

b. _____

c. _____

d. (PICTURED) _____

e. _____

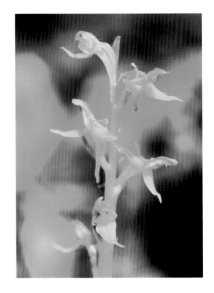

PINEAPPLE WEED

Matricaria matricarioides

The fernlike leaves give off a pineapple scent when crushed.

a. _____

b. _____

c. _____

d. (PICTURED) _____

e. _____

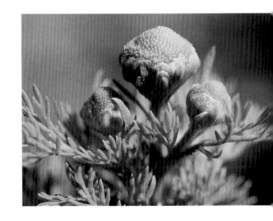

SHEPHERD'S PURSE

Capsella bursa-pastoris

The seedpods are shaped like an indented triangle, mindful of a shepherd's purse or a heart.

a.

b.

c.

d. (PICTURED)

e.

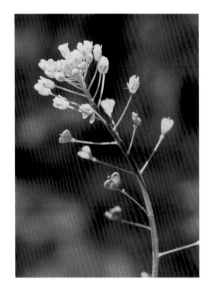

SHINLEAF ℬ

Pyrola elliptica

Dark olive green, broad, oval leaves cluster near the base of a multi-flowered stem.

a.

b.

c.

d. (PICTURED)

e.

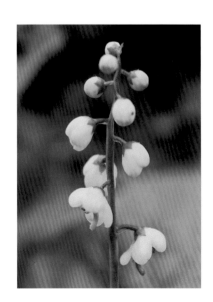

SHEEP SORREL

Rumex acetosella

This beautiful weed turns ruddy red brown and has a feathery appearance.

a. _____

b. _____

c. _____

d. (PICTURED) _____

e. _____

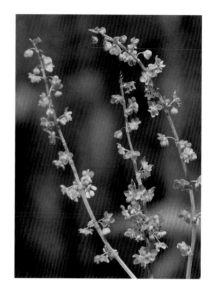

COMMON SPEEDWELL

Veronica officinalis

These diminutive, one-fourth-inch flowers on short stalks may be found growing in disturbed wooded areas.

a. _____

b. _____

c. _____

d. (PICTURED) _____

e. _____

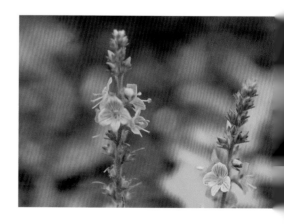

BIBLIOGRAPHY

Art, Henry W. *A Garden of Wildflowers: 101 Native Species and How to Grow Them*. Pownal, VT: Storey Communications, Inc., 1986.

Barker, Cicely Mary. *Flower Fairies: The Meaning of Flowers*. London: Warne, 1996.

Barton, J. G. *Wild Flowers*. London: Spring Books, 1963.

Bates, John. *Trailside Botany: 101 Favorite Trees, Shrubs, and Wildflowers of the Upper Midwest*. Duluth, MN: Pfeifer-Hamilton, 1995.

Burn, Barbara. *North American Wildflowers*. New York: Bonanza Books, 1984.

Busch, Phyllis S. *Wildflowers and the Stories Behind Their Names*. New York: Charles Scribner's Sons, 1977.

Cameron, Elizabeth. *A Wild Flower Alphabet*. New York: William Morrow and Co., Inc., 1984.

Clemants, Steven, and Carol Gracie. *Wildflowers in the Field and Forest: A Field Guide to the Northeastern United States*. New York: Oxford University Press, 2006.

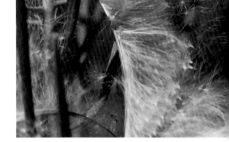

Coffey, Timothy. *The History and Folklore of North American Wildflowers*. Boston: Houghton Mifflin Co., 1993.

Connolly, Shane, and Jan Baldwin. *The Secret Language of Flowers*. New York: Rizzoli International Publications, Inc., 2004.

Courtenay, Booth, and James Hall Zimmerman. *Wildflowers and Weeds*. New York: Van Nostrand Reinhold Co., 1972.

Curtis, Edward S. *Native American Wisdom*. Philadelphia, PA: Running Press, 1994.

Densmore, Frances. *Strength of the Earth: The Classic Guide to Ojibwe Uses of Native Plants*. 1928. St. Paul: Minnesota Historical Society Press, 2005.

Doane, Nancy Locke. *Indian Doctor*. Charlotte, NC: Aerial Photography Services, Inc., 1980.

Dowden, Anne Ophelia Todd. *From Flower to Fruit*. New York: Ticknor & Fields, 1994.

Ehrlich, Gretel. *John Muir: Nature's Visionary*. Washington, DC: National Geographic Society, 2000.

Embertson, Jane. *Pods: Wildflowers and Weeds in Their Final Beauty, Great Lakes Region*. New York: Charles Scribner's Sons, 1979.

Ferguson, Mary, and Richard M. Saunders. *Wildflowers Through the Seasons*. New York: Arrowhead Press, 1982.

Friend, Hilderic. *Flower Lore*. 1886. Rockport, MA: Para Research Inc., 1981.

Heilmeyer, Marina. *The Language of Flowers: Symbols and Myths*. Munich and New York: Prestel Publishing, 2006.

Hill, Elaine A. *A Guide to Head-of-the-Lakes Wildflowers of Northwestern Wisconsin and Northeastern Minnesota*. Mountain View, CA: Moonlith Press, Inc., 1975.

Höhn, Reinhardt, with Johannes Petermann. *Curiosities of the Plant Kingdom*. New York: Universe Books, 1980.

House, Homer D. *Wild Flowers*. 1934. New York: Macmillan Publishing Co, Inc., 1961.

Janke, Robert A. *The Wildflowers of Isle Royale*. 1962. Rev. ed., Houghton, MI: Isle Royale Natural History Association, 1996.

Johnson, Lady Bird, and Carlton B. Lees. *Wildflowers Across America*. New York: Abbeville Press, 1988.

Kerr, Jessica. *Shakespeare's Flowers*. New York: Thomas Y. Crowell Co., 1969.

Ladd, Douglas M. *North Woods Wildflowers: A Field Guide to Wildflowers of the Northeastern United States and Southeastern Canada*. Helena, MT: Falcon Press, 2001.

———. *Tallgrass Prairie Wildflowers: A Falcon Field Guide*. Helena, MT: Falcon Press, 2005.

Lehner, Ernst, and Johanna Lehner. *Folklore and Symbolism of Flowers, Plants and Trees*. 1960. New York: Dover Publications, Inc., 2003.

Loegering, W. Q., and E. P. DuCharme. *Plants of the Canoe Country*. Duluth, MN: Pfeifer-Hamilton, 1978.

Martin, Laura C. *Wildflower Folklore*. Old Saybrook, CT: Globe Pequot Press, 1984.

Monserud, Wilma, and Gerald B. Ownbey. *Common Wild Flowers of Minnesota*. Minneapolis: University of Minnesota Press, 1971.

Moyle, J. B., and E. W. Moyle. *Northland Wildflowers: The Comprehensive Guide to the Minnesota Region*. 1977. Rev. ed., Minneapolis: University of Minnesota Press, 2001.

Newcomb, Lawrence. *Newcomb's Wildflower Guide: An Ingenious New Key System for Quick, Positive Field Identification of the Wildflowers, Flowering Shrubs and Vines of Northeastern and North Central America*. Boston: Little, Brown and Co., 1977.

Newmaster, Steven G., Allen G. Harris, and Linda J. Kershaw. *Wetland Plants of Ontario*. Edmonton, AB: Lone Pine Publishing, 1997.

Niering, William A. *Audubon Society Field Guide to North American Wildflowers, Eastern Edition*. 1979. New York: Alfred A. Knopf, 2001.

Oslund, Clayton, and Michele Oslund. *What's Doin' the Bloomin? A Pictorial Guide to Wildflowers of the Upper Great Lakes Regions, Eastern Canada and Northeastern USA*. Duluth, MN: Plant Pics, 2001.

Parker, Richard. *Wildflowers*. Miami, FL: Windward Publishing, Inc., 1986.

Peterson, Roger Tory, and Margaret McKenny. *A Field Guide to Wildflowers of Northeastern and North-Central North America: A Visual Approach Arranged by Color, Form and Detail.* 1968. Boston: Houghton Mifflin Co., 1986.

Pickles, Sheila. *The Language of Flowers.* New York: Harmony Books, 1995.

Reynolds, William. *Wildflowers of America.* New York: Gallery Books, 1987.

Robinson, Benjamin Lincoln, and Merritt Lyndon Fernald. *Gray's New Manual of Botany: A Handbook of the Flowering Plants and Ferns of the Central and Northeastern United States and Adjacent Canada.* New York: American Book Co., 1908.

Royer, France, and Richard Dickinson. *Weeds of the Northern U.S. and Canada: A Guide for Identification.* Edmonton, AB: Lone Pine Publishing, 2004.

Runkel, Sylvan T., and Alvin F. Bull. *Wildflowers of Iowa Woodlands.* Des Moines, IA: Wallace Homestead Book Co., 1979.

Sanders, Jack. *Hedgemaids and Fairy Candles: The Lives and Lore of North American Wildflowers.* Camden, ME: Ragged Mountain Press, 1993.

———. *The Secrets of Wildflowers: A Delightful Feast of Little-known Facts, Folklore and History.* Guilford, CT: Lyons Press, 2003.

Schinkel, Dick. *Favorite Wildflowers of the Great Lakes and Northeastern U.S.* Lansing, MI: Thunder Bay Press, 1994.

Smith, Beatrice Scheer. *A Painted Herbarium: The Life and Art of Emily Hitchcock Terry, 1838–1921.* Minneapolis: University of Minnesota Press, 1992.

Smith, Welby R. *Orchids of Minnesota.* Minneapolis: University of Minnesota Press, 1993.

Stensaas, Mark. *Canoe Country Flora: Plants and Trees of the North Woods and Boundary Waters.* Duluth, MN: Pfeifer-Hamilton, 1996.

———. *Wildflowers of the BWCA and the North Shore.* Duluth, MN: Kollath + Stensaas Publishing, 2003.

Vance, Fenton R., James R. Jowsey, and James S. McLean. *Wildflowers of the Northern Great Plains.* Minneapolis: University of Minnesota Press, 1984.

Wells, Diana. *100 Flowers and How They Got Their Names.* Chapel Hill, NC: Algonquin Books, 1997.

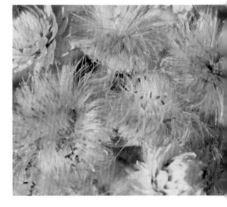

ACKNOWLEDGMENTS

MY PERSONAL THANKS to a good friend and to my family:

John Henricksson, my Gunflint Trail neighbor, for prodding, pushing, and encouraging me to complete this book. He was the stone in my hiking boot. He also took the candid shot of the young photographer over twenty-five years ago.

Betty Vos Hemstad, 1980

Judy Hemstad Anderson, for willingly, tirelessly, and skillfully organizing my lists and manuscript. Always a believer, she never lost sight of the goal at the end of the journey.

Nancy Hemstad Seaton, for continuing to "talk the wildflower talk" when others tired. A knowledgeable sounding board, she was the solid rock on my wildflower pathway.

Peter Hemstad, who provided a critique of my completed manuscript. He was the compass that helped me reach the final destination.

Ron Hemstad, for being my silent partner for over fifty years in all of my lifetime adventures. He deserves more credit than I can express here. He was the heart that kept a steady beat when the trail was difficult.

Betty Vos Hemstad, 2008

MY MOST SINCERE THANKS to my professional friends who generously shared their expertise:

Chel Anderson, gracious, respected northeastern Minnesota botanist, for making sure the scientific names and native and invasive plant designations were correct.

Jim Linhoff, for offering photographic counsel with the patience of a true friend for thirty years. The support of the color lab team at Linhoff Photo was appreciated.

Pam McClanahan, director, and Ann Regan, editor-in-chief, at Minnesota Historical Society Press, who saw the vision for this book and then gave it life.

Sean Jergens, MHS manuscript reviewer, for checking for botanical accuracy.

Will Powers, MHS Press production manager, for understanding how important it was to me that the colors in my photographs were true to nature's palette.

Cathy Spengler, respected book designer, who uses color and space with the touch of a master. My book was her canvas.

Lastly, my talented editor, Shannon Pennefeather, who heard my Boundary Waters voice, worked diligently with active verbs and commas, and wove my words into this wildflower paper tapestry.

I am profoundly grateful to all other relatives and friends who were supportive, encouraging, and understanding during the final stages of this project, especially those who shouldered an extra load because of my absence.

A final word of gratitude to those who carried *Wildflowers of the Boundary Waters* home with them. I hope you gained a keener appreciation for the wonders of wildflowers and you recognize the importance of protecting these treasures for future generations.

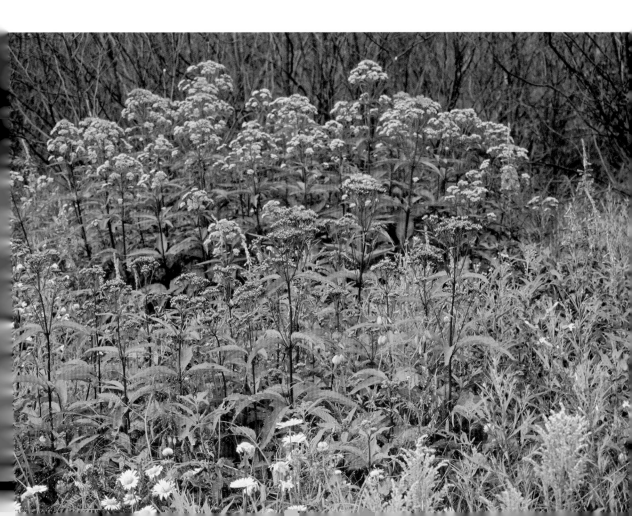

INDEX

rose, prickly wild, 58–59
Rubus idaeus, 108–9
Rubus parviflorus, 102–3
Rubus pubescens, 257
Rudbeckia hiria, 170–71
Rumex acetosella, 262

Sagittaria latifolia, 194–95
St. Johnswort, common,
 166–67
Sarracenia purpurea, 136–37
sarsaparilla, wild, 24–25
Scutellaria galericulata,
 184–85
sepals, 35
Shakespeare, William
 Hamlet, 245
 Henry v, 9
 *Midsummer Night's
 Dream, A,* 163
sheep sorrel, 262
shepherd's purse, 261
shinleaf, 261
Sibbaldiopsis tridentata,
 98–99
Silene csereii, 134–35
Silene latifolia, 100–101
Silene vulgaris, 134–35
Sium suave, 104–5
skullcap
 mad dog, 185
 marsh, 184–85
slender ladies' tresses, 122–23
smartweed, water, 210–11
Smilax officinalis, 25
Solidago, 238–39
Sonchus oleraceus, 218–19
sow thistle, common, 218–19
spadix, 91
spathe, 91
speedwell, common, 262
spikenard, 96–97
Spiraea alba, 116–17

Spiranthes lacera, 122–23
spur, 127
spurred gentian, 258
stamen, 5
starflower, 30–31
Stellaria graminea, 94–95
sticktights, 235
stigma, 5
Still, James, 97
stitchwort, lesser, 94–95
strawberry, common, 16–17
Streptopus lanceolatus, 52–53
style, 5
swamp candle, 231
sweet rocket, 82–83
symbols
 columbine, 54–55
 forget-me-not, 80–81
 pale corydalis, 56–57
Symphotrichium ciliolatum,
 248–49

Tanacetum vulgare, 236–37
tansy, 236–37
Thalictrum dasycarpum,
 92–93
thimbleberry, 102–3
thistle
 bull, 214–15
 Canada, 242–43
 common sow, 218–19
thorns, 59
toadflax, 225
touch-me-not, 221
Tragopogon dubius, 152–53
trefoil, bird's-foot, 158–59
Trientalis borealis, 30–31
Trifolium arvense, 144–45
Trifolium hybridum, 138–39
Trifolium pratense, 140–41
Trifolium repens, 106–7
Trillium cernuum, 20–21
trillium, nodding, 20–21

Tripleurospermum inodurum,
 190–91
twinflower, 60–61
twisted stalk, rose, 52–53

Utricularia vulgaris, 253

Vaccinium angustifolium,
 12–13
Vaccinium myrtilloides, 12–13
Verbascum thapsus, 228–29
Veronica officinalis, 262
vetch
 crown, 146–47
 hairy, 176–77
 tufted, 176–77
vetchling, pale, 40–41
Vicia cracca, 176–77
Vicia villosa, 176–77
Viola macloskeyi, 8–9
Viola pubescens, 64–65
Viola sororia, 76–77
violet
 common blue, 76–77
 dame's, 83
 downy yellow, 64–65
 sweet white, 8–9
Virginia bluebell, 79, 254
virgin's bower, 204–5

Walton, Izaak, 17
Water Lilies (Monet), 211
wildflower, 4
Wildflowers Across America,
 179
windflower, 10–11
wintergreen, 202–3
wintergreen, one-flowered,
 42–43
Wuthering Heights (Bronté),
 183

yarrow, common, 188–89

271

Wildflowers of the Boundary Waters was designed

and set in type at Cathy Spengler Design, Minneapolis.

The typefaces are TheSans SemiLight and Fontella.

Printed by 4-Colour Imports.